Images of Deception

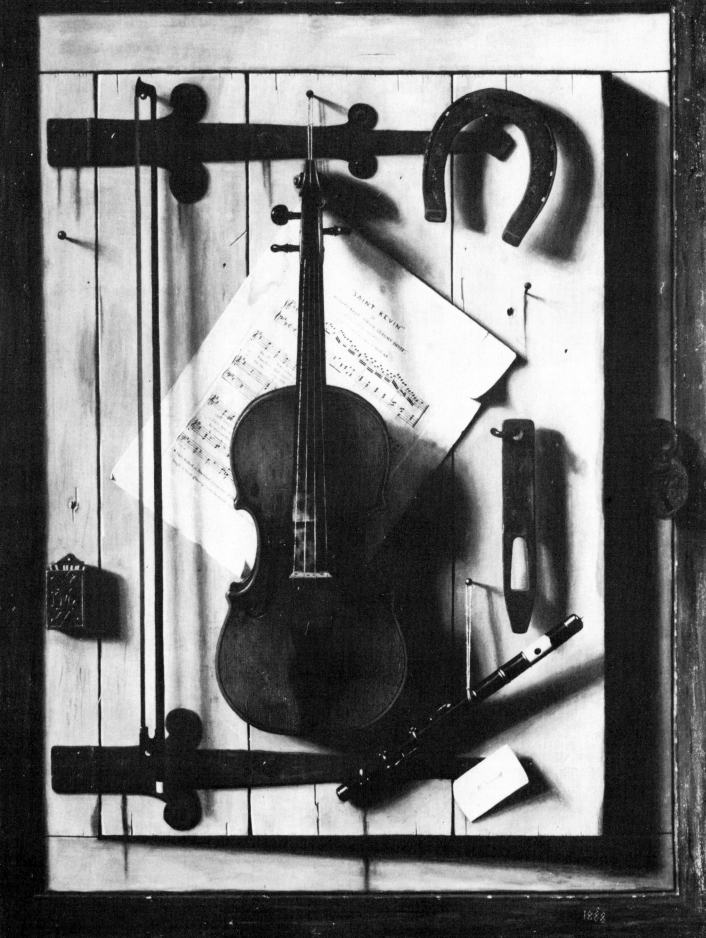

Images of Deception

THE ART OF TROMPE-L'ŒIL

Célestine Dars

Phaidon · Oxford

To Ted, with a wink

PG RT GC MP AS ET W BS VWM

Phaidon Press Limited, Littlegate House,
St Ebbe's Street, Oxford

First published 1979
Published in the United States of America
by E. P. Dutton, New York
© 1979 Phaidon Press Limited
All rights reserved

ISBN 0 7148 2000 8
Library of Congress Catalog Card Number: 79-83537

Printed in Great Britain by Waterlow (Dunstable) Ltd

Acknowledgements are due to the following agencies,
photographers and copyright holders:
Plates 2, 3, 11, 13, 18: Alinari; 4: Jean Ribière;
5, 9, 15, 19, 30, 31: Scala; 6, 27, 46: Caisse Nationale des
Monuments Historiques; 12, 20, 60: Michael Holford;
14, 21, 41: Connaissance des Arts/Guillemot; 16, 17, 29:
Boudot-Lamotte; 25: H. Petersen; 24: Agence Top/
Nahmias; 32: National Trust; 33, 34, 43, 44: Cooper-
Bridgeman Library; 35, 71, 72: Jac Remise; 36, 39, 59:
Connaissance des Arts/Hinous; 40: Musées Nationaux;
42: National Monuments Board; 45: Agence Top/
Desjardins; 47, 50: L. Jaulmes; 57: Snark; 64: Miki
Slingsby; 70: Paul de Gobert.

1 (frontispiece). William Michael Harnett (1848–92):
Music and Good Luck. Oil on canvas, 109 × 76 cm.
(43 × 30 in.) New York, Metropolitan Museum of Art,
Catherine Lorillard Wolfe Fund, 1963

List of Plates

Select Bibliography

Arndt, Hella, *Gartenzimmer des 18. Jahrhunderts*, Darmstadt, 1964

Battersby, Martin, *Trompe l'Oeil*, London, 1974

Bogaerts, Theo, *Kunst der Illusie*, The Hague, 1958

Carraher, Ronald G., *Optical Illusions and the Visual Arts*, New York, 1966

Connaissance des Arts, 1955–76

Frankenstein, A., *The Reality of Appearance: the Trompe l'Oeil Tradition in American Painting*, New York, 1970

Gloton, Marie-Christine, *Trompe l'Oeil et le Décor Plafonnant dans les Églises Romaines de l'Âge Baroque*, Rome, 1965

Gombrich, E. H., *The Story of Art*, Oxford, 1978 (13th edn)

Lagorio, H. J., *Imagery and Illusionism in Architecture*, Padua, 1967

Neumeyer, Alfred, *Der Blick aus dem Bilde*, Berlin, 1964

Otrange Mastai, M. L. d', *Illusion in Art*, New York, 1975

Sandstrom, Sven, *Levels of Unreality*, Uppsala, 1963

Trompe l'Oeil from the Eighteenth Century to the Present Day, exhibition catalogue, Arthur Jeffress Gallery, London, 1955

I would like to thank the artists and art gallery directors who have contributed helpful information, and more particularly Geoffrey Smith, who has so efficiently helped me with the editing.

Images of Deception

The art of trompe-l'oeil has been practised since the time of the ancient Greeks, but few people are aware of its existence or have ever seen an example of it. It has not been produced in great quantity, unlike subject painting, landscape and still-life, though it often resembles the latter and shares with it a certain feeling of intimacy. Trompe-l'oeil does not tell a story. It is as unemotional as it is clever. The trompe-l'oeil artist aims to create an illusion convincing enough to deceive the eye of the beholder by making a flat surface appear three-dimensional when the painting is finished. Thus, in a sense, his technical skill is meant to go undetected, which is not the usual case where works of art are concerned. The genre is essentially decorative and ambiguous and, purely practised, involves the following principles: an intent to deceive, perfect perspective in rendering the subject in order to achieve three-dimensional illusion, the exclusion of stylistic interference, and a surface treated as a whole entity.

What is the difference between trompe-l'oeil and an extremely realistic still-life? First of all, with the still-life there is no intent to deceive. If some objects are laid on a table, the table will only be partly represented and the viewer will have to imagine it whole. The same would apply to a drape hanging in the background, and so on. On the other hand, the trompe-l'oeil artist will not leave anything to the imagination. He will not allow any interpre-

tation beyond what he represents. Whenever he does, though incorporating elements of trompe-l'oeil in his composition and retaining his impeccable technique, he is then using it to emphasize his work's decorative aspect at the expense of pure trompe-l'oeil. This is particularly the case when human figures are included, as it is difficult to believe that anyone could mistake a painted body for a real one. In sculptural form, the human figure can enhance a trompe-l'oeil, but living beings, with their expected mobility, disturb the genre's make-believe world. Works of art include so many decorative elements that it may be difficult to determine whether the presence of a curtain, the use of perspective or the representation of natural elements such as stone or wood are meant to deceive the eye or are simply decorative complements. In many cases, the artist's intention may be unclear and we shall therefore limit ourselves to calling trompe-l'oeil, or incorporated elements of trompe-l'oeil, only what is obviously calculated to deceive us.

The first artist who tried to paint a trompe-l'oeil, the creator of the genre, had to be familiar with the basic principles of perspective geometry necessary to convey a sense of depth. He had to be skilful enough to represent objects with complete verisimilitude. And he had to have imagination and a certain sense of humour, because trompe-l'oeil is literally a visual trick, the artist's purpose

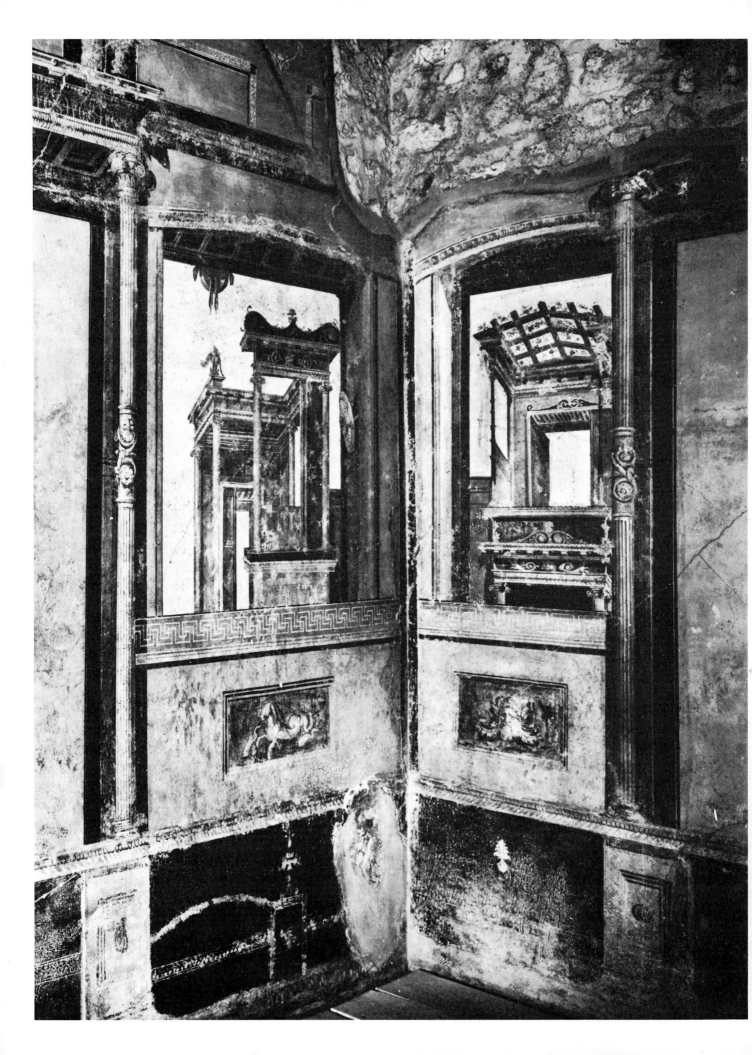

being to create a complete visual illusion. Such a man was therefore the product of a rather sophisticated society. We can in fact presume that he was a Greek citizen.

The ancient Greeks had a passion for geometry. Their practice of carving the tall columns of their temples slightly convex to correct the distortion of perspective from the ground is an incipient form of trompe-l'oeil. Except as vase decoration, Greek painting has scarcely survived, yet good painters were highly praised. In his *De Architectura* written during the first century A.D., the Roman Vitruvius mentions a very illusionistic backdrop by a famous Greek artist, Agatharchos, for a tragedy by Aeschylus. A contemporary anecdote describes how two Greek painters challenged each other to see who could best deceive the public's eyes. There have been many similar stories since, most of them telling how people and animals alike have been taken in by the verisimilitude of some trompe-l'oeil.

The earliest extant trompe-l'oeil paintings date from the Roman era. They are frescoes from the walls of villas, the best known being from Herculaneum and Pompeii. The lava that burst from Vesuvius in A.D. 79, burying these cities, preserved intact their mode of life, including the refined manner in which the more affluent citizens decorated their homes. Bronze and marble statues, mosaic floors and painted walls abound. Trompe-l'oeil was a favourite means of decoration, as it increased the feeling of space and adorned bare walls attractively. We shall find that mural trompe-l'oeil remains an Italian speciality and this is quite natural since a warm Mediterranean country has a lot of light and little need for the comfort of drapes.

Roman painters tried a number of visual effects and their works seem at times more experimental than deliberately illusionistic. The wall of the Casa dei Grifi in Rome, for instance, looks like an artist's sampler despite its symmetrical composition. Their favourite inspiration was the theatre and their most common motif the elements of theatrical architecture. They aimed to simulate complete buildings within the actual building itself, with marble-like columns, fanciful capitals and other additions such as masks and garlands. The overall effect was often rather heavy and, since the Romans did not completely succeed in mastering perspective, these murals are not very convincing as trompe-l'oeil (Plate 2). Nor were the Romans successful in using mosaic to realize less ambitious trompe-l'oeil. Mosaics are made of numerous small coloured stones and can hardly be expected to promote realism, even if the craftsman has thought of completing the effect by means of shadows. The best surviving example of mosaic trompe-l'oeil is the *Unswept Floor* (Plate 3), made during the second century A.D., but copied from a Greek original of the third or second century B.C. It shows a floor littered with domestic debris.

With the decline of the Roman empire and its final collapse at the hands of the Goths, trompe-l'oeil disappears until the Middle Ages. There are, in the Romanesque era of the eleventh to twelfth century, some rare attempts at creating optical illusion, such as the simulated arches and pillars of two baptisteries in the chapel of the kings of Majorca at Perpignan and at Palma de Majorca (Plate 4). They may be the work of the same artist and are exceptional at a time when the general style was two-dimensional, lacking perspective, volume, and therefore shadow. In fact, it is only with the rediscovery of perspective at the

2. Roman architectural mural. About 70 AD. Pompeii, House of the Vettii

9

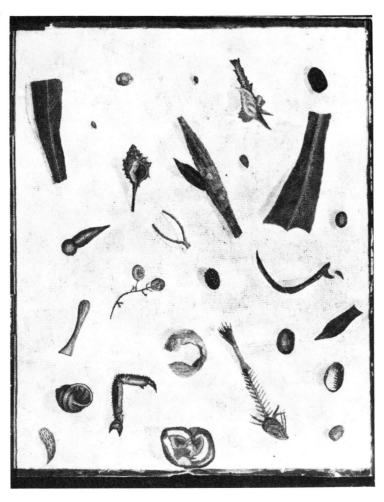

3. *Unswept Floor*. Roman mosaic. 2nd century AD. Rome, Lateran Museum

start of the Italian Renaissance, *c.*1300, that we find the first traces of potential trompel'oeil.

In the work of Giotto, the flatness of the Dark Ages begins to disappear, to be progressively replaced by depth and volume, just as rigidity is supplanted by a grace reflecting the oriental influences brought to Italy by Venetian merchants. Taddeo Gaddi (active 1313-45), Giotto's pupil and faithful follower, was to add the essential element of shadow. The Florentine school, to which both painters belonged, was blossoming with talented artists who worked close to each other. The architects were deeply involved in the study of perspective and foreshortening, and what they built the painters decorated. Some artists had a good knowledge of both architecture and painting—and all had undergone long apprenticeships under respected masters. Similarly, at a time when cities were emerging as the major centres of the country, the artists benefited from the rivalry, the intense competition for pride and prestige that turned urban rulers into patrons of the arts. With a new desire to depict what they saw, painters started to sketch from nature. They wanted to emulate the Greek and Roman success in representing the human body. In these terms, the works of Giotto were the first major departure from the Middle Ages.

If Giotto was the first painter to free himself from the medieval view of painting, it can be said that Brunelleschi (1377–1446) was the first architect to embody the ideals of the Renaissance. A Florentine, Brunelleschi spent years studying the ancient buildings of Rome and succeeded in creating an entirely original architecture based on the classical style. He worked in Florence and there solved the problem of perspective mathematically, which no one had done before him. To his contemporaries, the discovery was a revelation. It was to be thoroughly explored and exploited

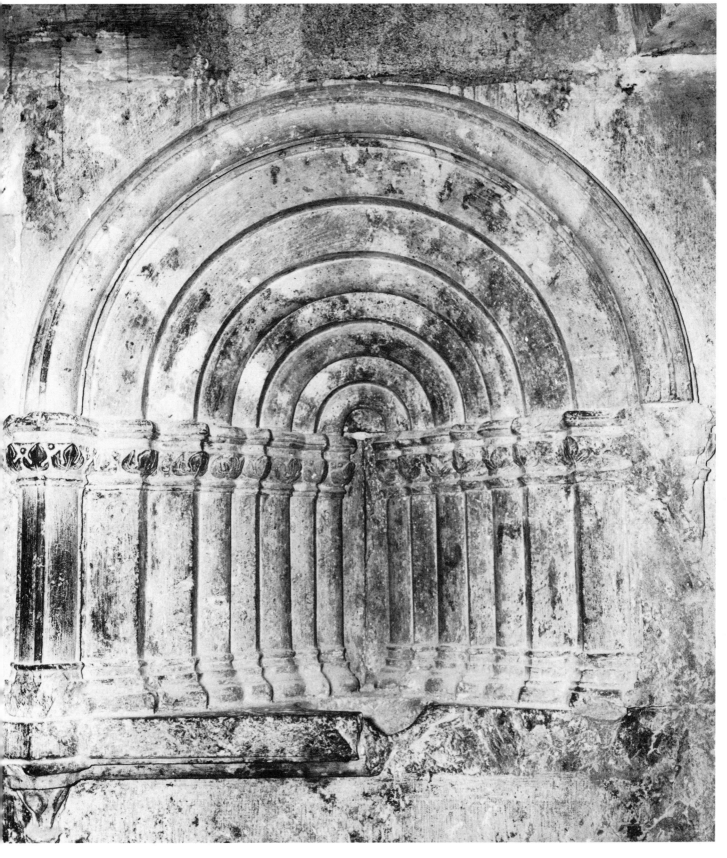

4. Simulated arches and pillars. 12th century.
Perpignan, France, baptistery in the chapel of the palace of the kings of Majorca

by succeeding generations and remains the basic study of every artist.

The first major applications of Brunelleschi's discovery are found in Masaccio's paintings. *The Holy Trinity, with the Virgin, St John and Donors* (Plate 5), which he completed a year before his death in 1428 at the age of twenty-seven, is remarkably statuesque and looks very much as if his main interest had been in painting the elaborate perspective of the structure. He would have achieved a real effect of trompe-l'oeil, the first truly scientific instance we know, were it not for the presence of saintly figures, as we cannot for one moment believe in their carnal reality. One can see that complete illusion was not indeed Masaccio's object. Donatello (*c.*1386–1466) was also a man of major importance in the development of Renaissance art. He was a sculptor, but his work influenced many fifteenth-century artists. His statues possess life, movement and a grace unknown to the Gothic age, and he used perspective as well so as to give a great sense of depth to the flatness of reliefs. Although few sculptures have been meant to deceive the eye or be used in an illusionistic context, Donatello certainly helped to spread an awareness of illusionistic possibilities.

Ideas spread throughout Europe, from town to town and court to court. Influences were assimilated in various degrees by people of very different natures and environments. The Italians were to retain their supremacy in mural paintings, their works being often bold and lyrical, while the northern artists were masters of precision and detail, more intimate in style and therefore particularly suited to still-life painting rather than murals.

The great name of the North was Jan van Eyck (1390?–1441), who was closely associated with the court of the dukes of Burgundy and seems to have been the first successful 'photographic' painter. His famous *Betrothal of the Arnolfini*, painted in 1434, shows with complete accuracy the richness and detail of each object, above all the discreet centrepiece—the round convex mirror reflecting the couple's backs and the artist himself standing in the doorway. Van Eyck was not satisfied with the medium in general use at his time—tempera—which consisted of ground pigments mixed with egg. He probably found that it dried too quickly for the length of time the quality and precision of his work required. Instead of egg he used high-quality oil, a much more flexible medium that produced translucent effects, giving the surface a soft luminosity.

Van Eyck came very close to using trompe-l'oeil, notably on the reverse of his *Ghent Altarpiece*, a polyptych painted in 1432. The two panels are divided into twelve compartments. Two of them represent stone statues of saints painted in tones of grey with great verisimilitude, but it cannot have been the painter's intention to deceive the public's eyes. The surrounding panels do not permit such an illusion and these two panels seem to have been incorporated following the traditional practice.

Altar triptychs were among the most beautiful works produced in the fifteenth century. They were shown open in all their glory during the religious ceremonies and kept shut the rest of the time, when the two side-panels were folded over the central one. Quite naturally, the reverses of these panels were painted with great care but less opulence. Many artists chose to paint statues of saints in grisaille, so that the panels became part of their architectural surroundings and did not disturb the concentration of those who came to pray. It is these panels that are true trompe-l'oeil (Plate 6). The word grisaille comes from the French *gris* (grey). It means painting a subject in various tones of that colour. It is a good exercise for studying the

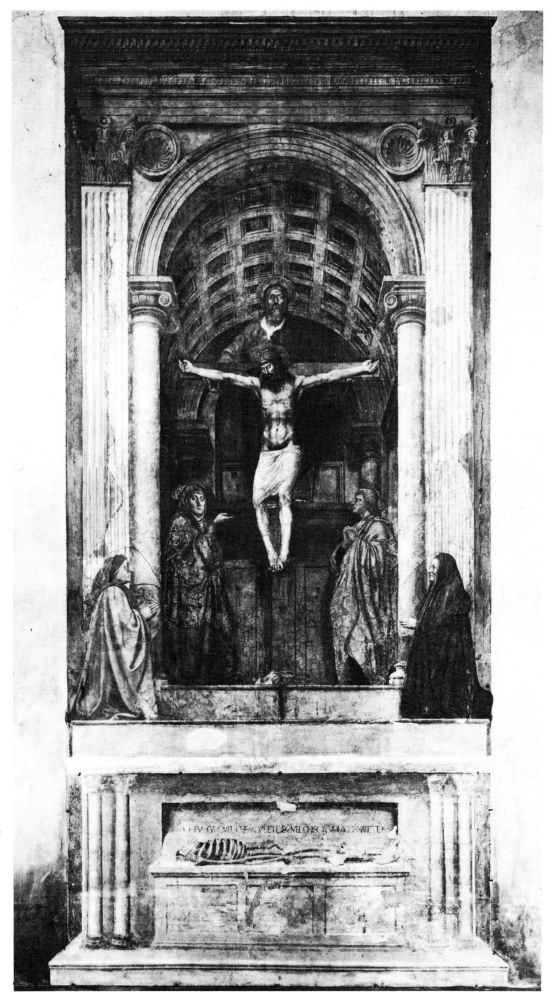

5. Masaccio (1401–c.1428):
*The Holy Trinity, with
the Virgin, St John and
Donors.* About 1425–28.
Fresco. Florence, Sta
Maria Novella

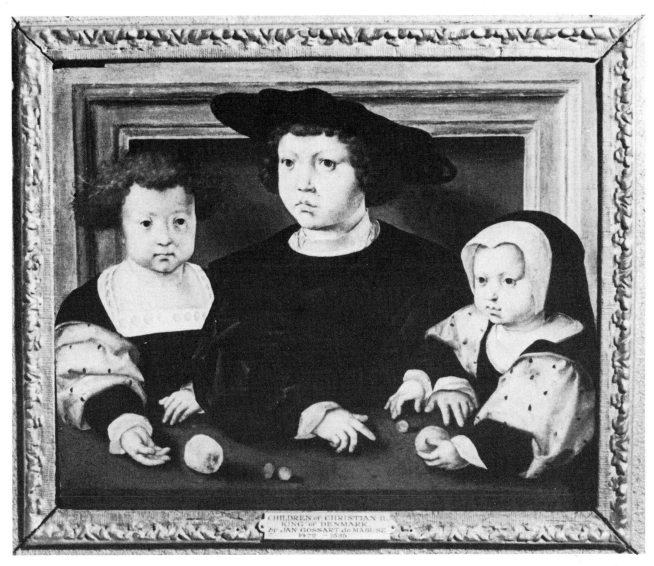

6 (left). Nicolas Froment (active 1540–90): *The Angel Gabriel and the Virgin Mary*, reverse panels of the Burning Bush altar triptych. 1475. Panels, each 305 × 110 cm. (120 × 43½ in.) Aix-en-Provence, cathedral

7 (above). Jan Gossaert de Mabuse (c.1472–c.1533): *The Children of Christian II of Denmark*. c.1510. Oil on canvas, 32.4 × 40 cm. (12¾ × 15¾ in.) Collection the Earl of Pembroke

variations of light and shade and was used to simulate stone reliefs or statues.

Other devices emerged to increase the realistic effect. The most obvious of these and one that was to remain a frequent feature of trompe-l'oeil is the piece of paper called *cartellino*, bearing a dedication or a signature. Typically, it will seem a casual addition to the work, showing the trace of a fold, an up-turned corner or other signs of wear and tear as evidence of its authenticity. A characteristic usage occurs in *Salvator Mundi*, by Antonello da Messina, painted in 1465. It is perhaps the first deliberate anecdotal trick, quite different from an extensive use of perspective.

Artists evolved with their times and, from the Renaissance onwards, they progressed at a remarkable pace. The Church still had considerable wealth and influence, but had lost the absolute supremacy it had shared with the feudal lords. As trade increased, cities swelled and burghers became very influential. The profane challenged the sacred and individuals achieved a greater importance. At this time appear the first guilds, ancestors of the trade unions. They were designed to protect

15

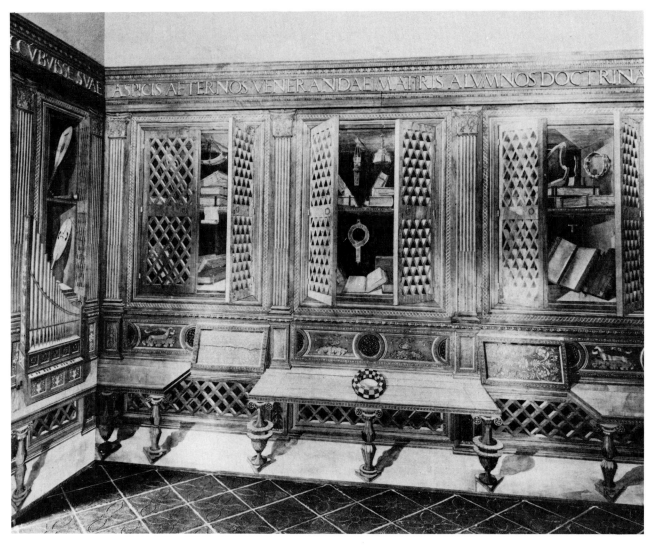

8. Francesco di Giorgio (1439–1502): *Studiolo*. About 1465.
Panel. New York, Metropolitan Museum of Art, Roger Fund, 1939

the rights and privileges of experienced artists and craftsmen. They showed that such men had become well-established enough to claim a certain independence and were conscious of the value of their talent to society. It became the practice for artists to sign their works— and these were often portraits of wealthy merchants and their families. The artists made great use of the science of perspective to give depth or bring life to their sitters and their surrounds: open doors in the background, curtains, ledges in the foreground, and such-like (Plate 7). It was also used in painted books, where the religious subjects of illumi-nations assume less importance than the decorative elements that surround them. Those are mostly insects, feathers, coins, shellfish or flowers that seem to be held by slits cut into the pages. These decorations were more an exercise than a deception since the reduced scale of the objects made it impossible to be mystified, but they are a charming innovation (Plate 9). The Italians successfully tried other decorative techniques. They used *intarsia*, the art of forming pictures and motifs with thin veneers of different woods. Two crafts-men, the Landinara, invented a process which consisted in dyeing the wood by boiling.

16

The stalls of the Santo in Padua are the first examples of this technique (1462–69). Stalls, music desks, cabinets and studies (*studioli*) were decorated in this fashion. Botticelli (1446–1510) designed the *studiolo* at Urbino, but even more successful is the *studiolo* attributed to Francesco di Giorgio (Plate 8) in the palace of Gubbio, residence of Duke Federigo da Montefeltro. Latticed half-open doors reveal the inside of cupboards, the shelves laden with musical, domestic and scientific instruments. Everything is shown in perspective and in perfect proportion, whereas Botticelli included less convincing figures and landscapes. The duke was an enlightened connoisseur to whom Piero della Francesca dedicated his treatise on geometry.

During the Renaissance, the artists worked within the walls of their respective cities, developing local styles which we now identify as schools. Reflecting its immediate influences, northern architecture was following the Gothic tradition. Such churches did not offer large surfaces for decoration and light was often poor on the side walls. Pillars and columns were placed at regular intervals and wood panelling was preferred to the vulnerable fresco painting. In private residences, tapestries and wood panelling created a warmer environment than murals. The Italians, on the other hand, were inspired by the Roman antiquities that surrounded them and had also started to collect fragments brought from Greece. Thus Piero della Francesca and Mantegna were able to paint figures clad in relatively accurate Roman dress, whereas previous artists represented historical characters in costumes similar to their own. (This attention to accurate details is characteristic of the Renaissance taste for realism.) Walls and domes offered large areas for the painters to cover. They were often bathed in a soft, warm light—and light had become nearly as important as perspective.

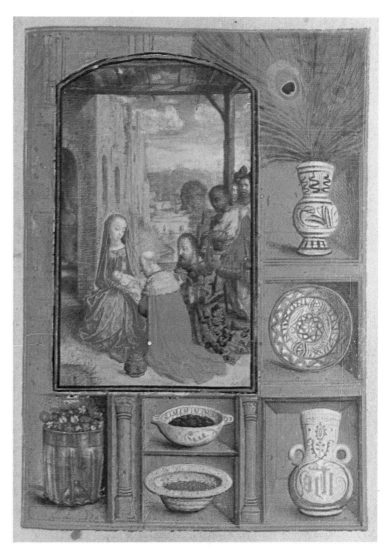

9. Master of Mary of Burgundy: Illuminated page from the *Englebert Book of Hours*. About 1585–90. Vellum, 11.4 × 8.9 cm. (4½ × 3½ in.) Oxford, Bodleian Library

It seems very strange that light should have had to be discovered by the southern artists, and yet it plays no greater part in the medieval Italian works than in works from any other country. As the Renaissance artists started to look and observe intensely, they became aware of the obvious importance of light. (After all, its complete study, particularly of its effect on colours, was only to be carried out by the Impressionists in the nineteenth century.) So, light and plane surfaces were the two factors that allowed the Italians to evolve considerably away from the medieval tradition still followed by their northern counterparts.

17

With Mantegna (1431–1506), we find that trompe-l'oeil could be applied on a larger scale. Commissioned to decorate the so-called nuptial bedroom (*camera degli sposi*) in the ducal palace of Mantua (Plate 10), he combined Roman style and themes with the techniques of trompe-l'oeil, making the dome look larger than it is by painting the oculus as an open sky from which cherubs and figures peer down. The rest of the ceiling is treated as a relief so rich in details as to look nearly baroque. Thus trompe-l'oeil was firmly moving into architecture, enlarging the whole design by the illusion of perspective. Relief trompe-l'oeil was also to become popular. It contrived to imitate the effects of reliefs generally carved in marble and was therefore monochrome. It could achieve a great decorative effect, was less costly and, as is the case with all mural trompe-l'oeil, gave more latitude to the artist, less restrained by a predetermined surface.

The sixteenth century produced an exceptional number of outstanding talents in all fields. Italy remained the leader of the arts with Leonardo da Vinci, Michelangelo, Raphael and Titian among many others. But in the North appeared men like Holbein, Dürer, Bruegel and Hieronymus Bosch. It was during this century that Pope Julius II asked Bramante to build the basilica of St Peter's in Rome, but it was also the time of Luther, Calvin and the Reformation— a serious threat to the powerful Catholic hierarchy—that was to split Europe intellectually and politically. It was a century of prestigious and warring monarchs: Henry VIII, followed by his daughter Elizabeth I in England; Louis XII and François I of France, who both tried to conquer northern Italy and returned home with Italian artists; the emperor Maximilian I, and the formidable Charles V of Spain, who also controlled part of the Netherlands. The Borgias reigned in Rome.

Men had started to look. They now wanted to study seriously what they saw, to query and solve the many enigmas of life. It was the beginning of the scientific age, a new direction for man's insatiable mind. The anatomical and other scientific sketch-books of Leonardo da Vinci are perfect examples of the spirit of the time. The increasing complexity of the works of art reflecting this spirit makes it difficult sometimes to distinguish illusionistic effects from pure trompe-l'oeil. Indeed, many artists used perspective only in order to achieve a certain degree of illusion. This is the case with Michelangelo's ceiling in the Sistine Chapel, where the 'architecture' that provides the composition's structure is purely illusionistic. Had Michelangelo decided to leave the figures out, he would have achieved a complete trompe-l'oeil. This was obviously not his purpose and the addition of figures prevents us from being mistaken.

Artists were now so skilful that trompe-l'oeil could be applied to a great variety of decorative projects, even ceramics. Traditionally, majolica was decorated lavishly on plain surfaces. A Frenchman, Bernard de Palissy (1510–1589), improved the technique of firing and enamelling and produced very unusual pieces in the trompe-l'oeil manner, which were much praised by the French court. He made dishes laden with fish and shellfish or with fruit. They are more original than aesthetically satisfying and, if the artist's intention was real deception, they are not convincing enough—at least to the modern eye.

Rich patrons were entertaining splendidly, and we know, although none of the works have survived, that they commissioned artists

10. Andrea Mantegna (c.1431–1506): *Camera degli Sposi*. About 1475. Fresco. Mantua, Palazzo Ducale

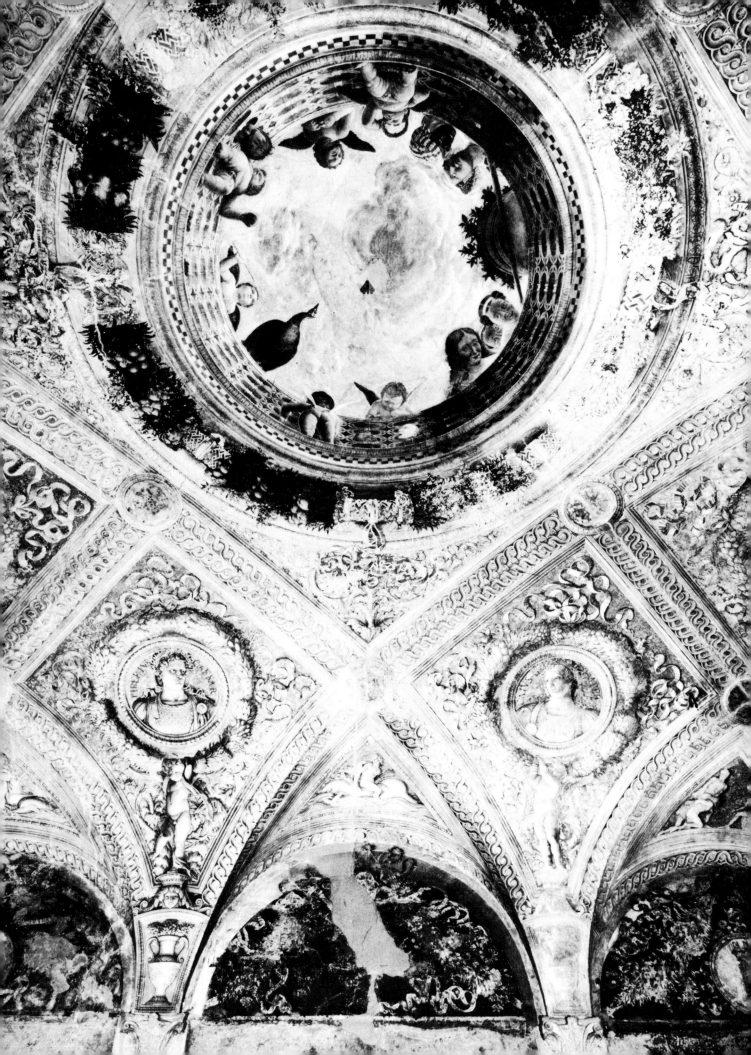

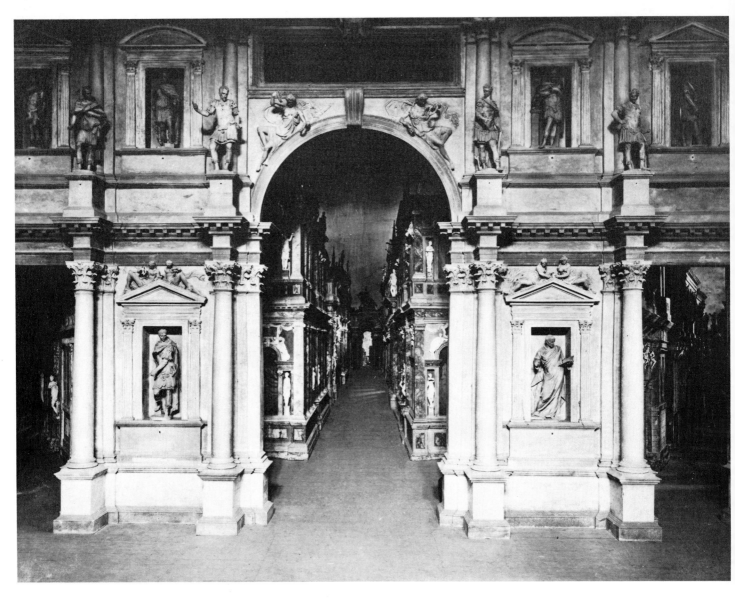

11. Andrea Palladio (1508–80): Stage set for the Teatro Olimpico, Vicenza. Built 1579–81

of the stature of Leonardo and Piero della Francesca to paint the triumphal arches and décors—many pure trompe-l'oeil—used in their magnificent festivities. Some of these *trionfi* were decorated in the Roman manner. At first, the artists painted reliefs on canvas and they later painted coloured trompe-l'oeil of what the reliefs represented. The artists were retained by their employers and were at their disposal. It seems a pity that Leonardo should have absorbed himself in ephemeral decorations, but this was a very usual practice, since artists were also considered to be craftsmen.

At this time the theatre was developing as well as the opera—under the influence of Monteverdi (1567–1643). Artists designed theatrical sets, the best-known being conceived by the architect Palladio, whose last work was a stage perspective with an illusionistic view of a street in the Roman classical style (Plate 11). Elements of the theatre were

20

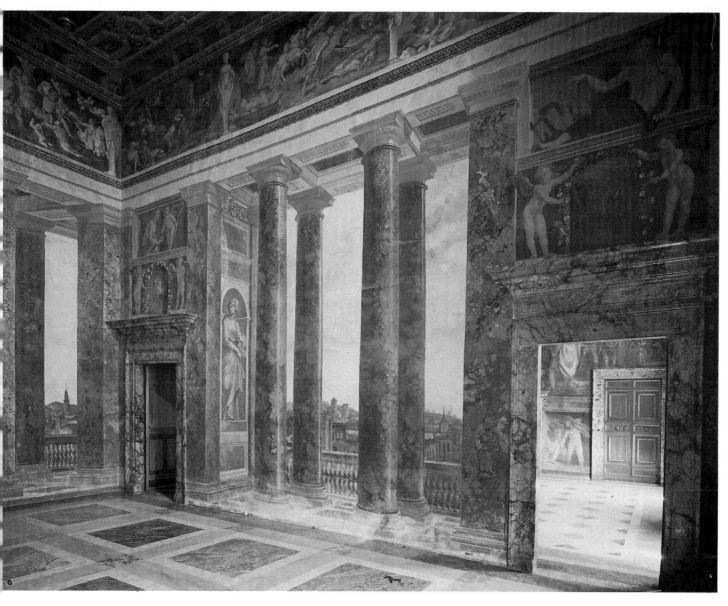

12. Baldassare Peruzzi (1481–1536): *Hall of the Columns*. About 1516.
Fresco painted to simulate a view of Rome. Rome, Villa Farnesina

brought into mural paintings by other artists, such as Friedrich Sustris and Alessandro Scalzi, who, in 1575–9, introduced characters from the Commedia dell'Arte into their trompe-l'oeil decorations of the staircase at Trausnitz castle in Landshut, when they were working for Wilhelm V of Bavaria. However, life-size figures appearing on balconies, galleries, and through open doors detract from complete architectural illusion, even more here since the costumes are contemporary.

Much more convincing is the *Hall of the Columns* (Plate 12), painted by Baldassare Peruzzi in about 1516 in the Villa Farnesina in Rome, and interiors of churches where the only figures are statues. Trompe-l'oeil was unquestionably cheaper than real architecture. It could achieve similar effects, and—much more—achieve feats that were architecturally impossible, thus introducing an element of fantasy. It appealed to a society hostile to the simplicity of bare walls.

21

We can still see today in Varallo, a city of Piedmont, how effectively the art of trompe-l'oeil could be used by imaginative and talented artists. They were often not only painters but architects and sculptors as well and could excel in any of these arts. Such a man was Gaudenzio Ferrari (1484?–1546), a probable student of Perugino and a close friend of Raphael, with whom he went to Florence and Rome. In Rome, he helped Raphael to decorate the Farnesina and parts of the Vatican. Later, Ferrari collaborated with Giulio Romano, then went to Varallo in 1521, where he had previously worked in 1504. He decorated the church of the Sacro Monte and made sculptures for two chapels, of which the most interesting is the chapel of the Crucifixion (Plate 13). Ferrari tried to create a complete environment by using frescoes and sculptures, so that the principal 'actors' of the scene are three-dimensional figures standing in front of the crowd painted on the walls. If there is a certain naïvety in some of the figures, they are on the whole remarkably lifelike in a baroque manner not expected in the late Renaissance era. This very unusual setting seems to replace the Passions formerly enacted by villagers in the churches in the Middle Ages. It was also meant to educate the populace, as wall paintings and the capitals of Romanesque pillars had done previously. This may account for a realism we do not find in Ferrari's painted work, and that will only reappear nearly a century later with Caravaggio. Many of these painted, glass-eyed and bewigged terracotta figures were later destroyed, but such settings were popular at the time of the Counter-Reformation.

Trompe-l'oeil was introduced on façades during the sixteenth century. In Basle, Hans Holbein the Younger (1497–1543) painted a whole house in this style. Only a model remains in the Basle museum. Exterior trompe-l'oeil became very fashionable in central Europe during the Italian Renaissance and one of the best remaining examples can be seen at the castle of Ambras in Austria, where the walls of the courtyard were entirely painted in grisaille by Heinrich Teufel in 1567–8 (Plate 14). The project was commissioned by the Archduke Ferdinand II of Austria, nephew of Charles V of Spain, whose life shows well how the Renaissance penetrated the Catholic countries north of Italy. Ferdinand was a man still attached to medieval customs like jousting, and court life at Ambras was very coarse by Italian standards. Yet his interest in science and, to a minor degree, in art, was that of a Renaissance man, hence the somewhat naïve-looking grisailles of the courtyard. It is strange that central Europeans should have been so fond of decorations painted out of doors, as these could be expected to deteriorate more rapidly than in a warm and dry climate.

Illusionistic effects were employed to the point of total extravagance by the seventeenth- and eighteenth-century Italians, when the Venetian and Roman schools supplanted the Florentines. The successors of the Renaissance masters turned away from classical sources (Plate 14). New concepts in the planning of churches incorporated basic elements of the Byzantine style. They were built in the shape of a Greek cross, with additional chapels on the sides and a large dome erected in the centre. Exuberance characterized the accompanying decoration, reflecting Catholicism's response to the more austere Protestants. The powerful and sculptural style of Michelangelo gave way to a style in which nothing was static, save the trompe-l'oeil architecture of the ceilings. These served as a structural back-

13. Gaudenzio Ferrari(?1484–1546): Fresco with painted sculptures in the foreground. After 1521. Lifesize. Varallo, Sacro Monte, Chapel of the Crucifixion

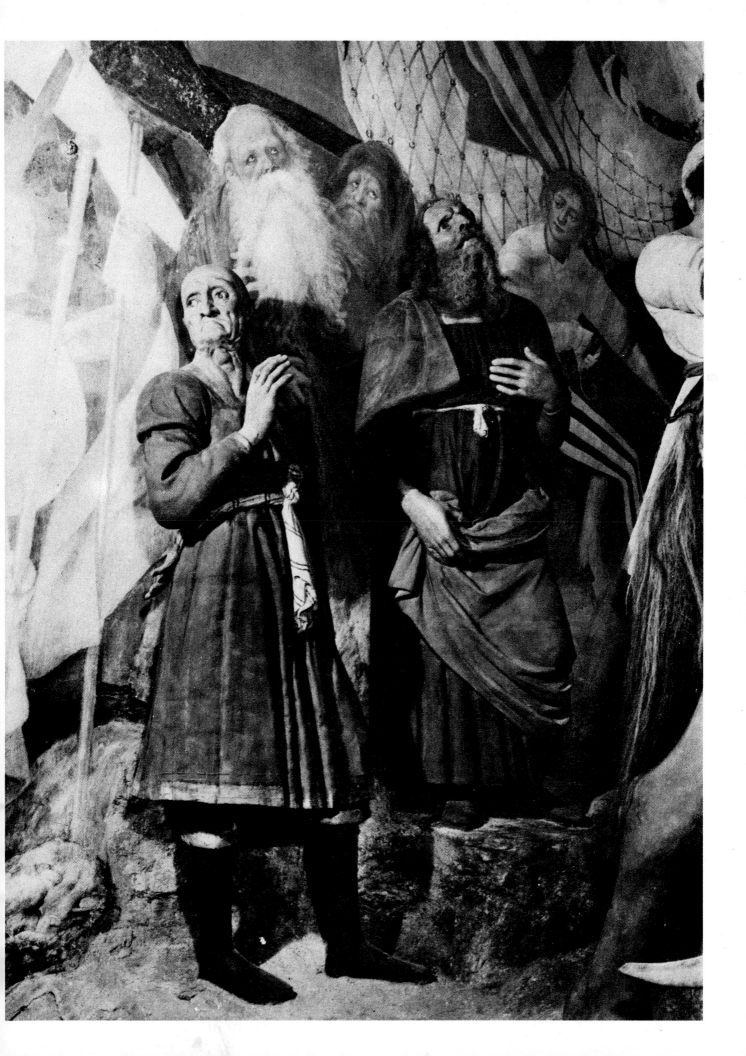

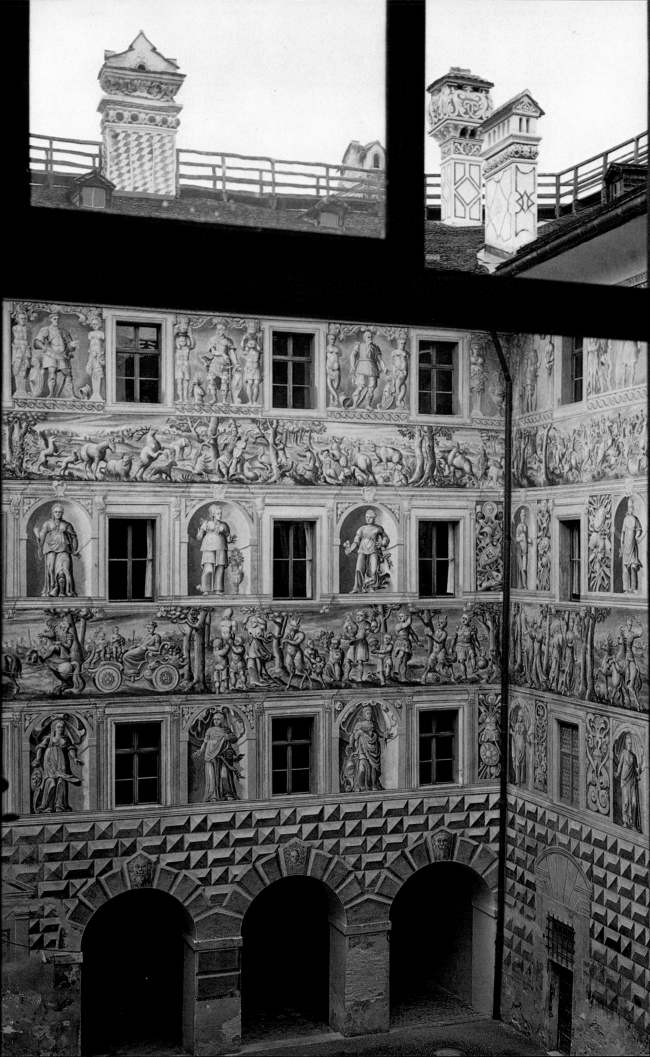

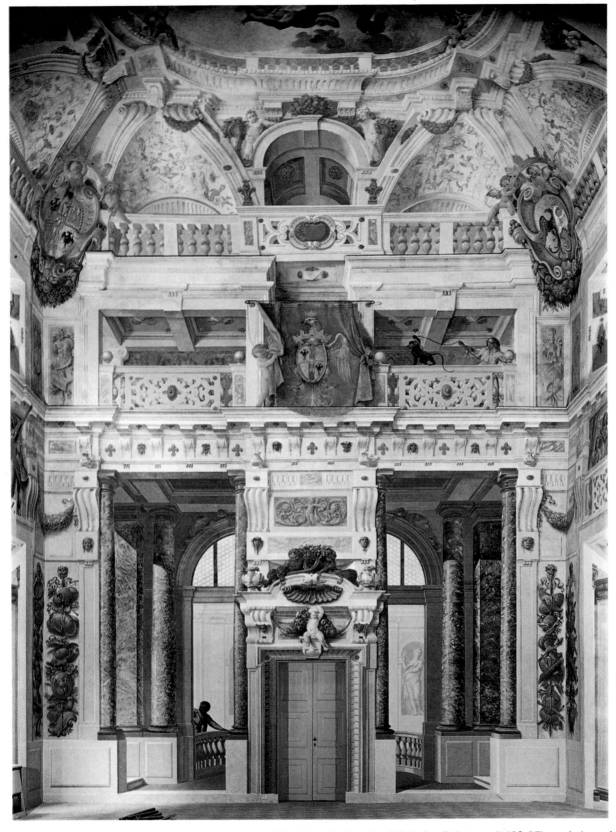

14 (left). Heinrich Teufel (d.1570): Walls of the courtyard at Ambras, Austria. 1567–8

15 (above). Angelo Michele Colonna (1600-87) and Agostino Mitelli (1609-60): Wall decoration in the Salone delle Guardie. Mid-17th century. Sassuolo, Palazzo degli Estensi

16. Fresco decoration of the cupola in the parish church at Weisentheid, Austria. Architect Balthasar Neumann (1687–1753)

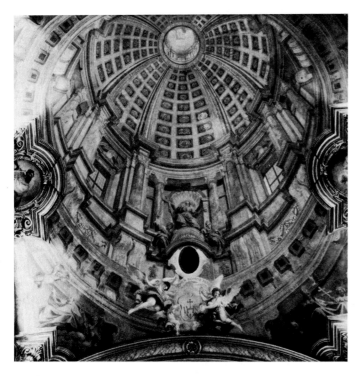

17. Andrea Pozzo (1642–1709): Fresco decoration of the cupola in the Jesuit Church, Vienna. After 1702

ground and were the only symmetrical element in compositions depicting flights of semi-draped whirling figures ascending towards heavenly skies. Symmetry had gone, replaced by the lively disorder of crowds and clouds.

It is significant that many of these churches should have been built for the Jesuit order, founded by Ignatius Loyola in 1534–7, when it became obvious that the Protestant schism had become irreversible, and also when Henry VIII had decided—for private and political reasons—to remove the English Church from papal control. The Jesuits became the spearhead of the Vatican. The most militant of all the religious orders, they were very active in all Catholic countries as well as in the parts of South America newly occupied by the Spaniards. The first churches built at the time of the Counter-Reformation were sober in decoration, but by the late seventeenth century, it was felt the glory of God deserved all the lyrical exaltation the artists could muster. New churches as well as the older ones were decorated in this manner, now commonly known as the Jesuit style (Plate 16).

The Jesuit Andrea Pozzo (1642–1709) was a remarkable exponent of the genre (Plate 17). He worked for many churches of his order, mainly in Rome, where he decorated the ceiling of the church of S. Ignazio between 1685 and 1694 with excellent trompe-l'oeil. He also painted many false cupolas. In 1702, the Emperor Leopold invited him to Vienna, where he decorated several churches and had a strong influence on Austrian artists. He also published in 1693 a treatise on perspective, *Perspectiva Pictorum et Architectorum*, which was so successful that it was translated into German and English. An architect as well as a painter, he designed the church of Vienna University.

This ecstatic style was later called Baroque

by its detractors—literally eccentric, bizarre, irregular—in short, the opposite of classicism. Guercino, Pietro da Cortona, Giovanni Battista Gaulli and scores of excellent artists produced its masterpieces, which are often no more intended to be trompe-l'oeil than was the Sistine Chapel. Some of the richest decorations are found in the spacious private residences, more appropriately called palaces, which had long replaced the feudal castles. Murals featured mythological themes and symbolism such as Dawn, the Ascent of Apollo, the Triumph of Venice. Life and movement were the predominant characteristics of both religious and secular decorations. with figures loosely clad in a pseudo-classical fashion completely unrelated to contemporary costume, since concern for realism had waned (Plate 19).

At the same time, if we return to Varallo, we find a unique and little known sculptural tradition being pursued. In order to complete the work begun nearly a century earlier by Gaudenzio Ferrari, the painter Tanzio da Varallo (c.1575–1636) was commissioned to decorate other chapels of the church of the Sacro Monte in the same fashion (Plate 18). This time, the sculptures were made by his brother Giovanni d'Errico and the realistic character is much more in tune with the paintings of their contemporary Caravaggio (1573–1610). The two brothers worked at the first two chapels between 1616 and 1620, Giovanni executing the nineteen sculptures of the first while his brother was in Rome. The subject is Christ before Pilate, while the second chapel, containing sixteen figures, depicts Pilate washing his hands. Later, the church was enlarged and the brothers completed a third chapel (there are over fifty in Varallo), erected in 1619. This is the most ambitious; its thirty-five statues represent Christ brought before Herod. At first glance, this achievement might seem slightly folk-

18. Tanzio da Varallo (c.1575–c.1636) and Giovanni d'Errico (d.1644): Fresco with painted sculptures in the foreground. About 1616–20. Terracotta, lifesize. Varallo, Sacro Monte, Chapel 34

27

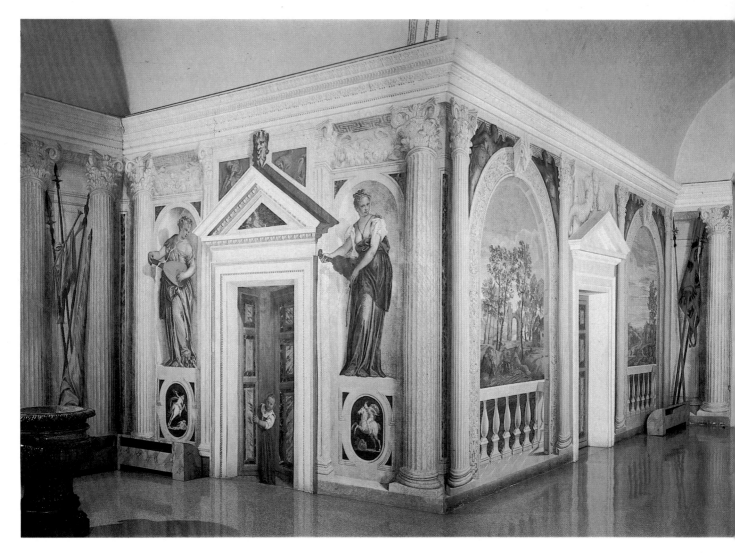

19 (above). Paolo Veronese (c.1528–88): Architectural mural. About 1560. Fresco. Maser, Villa Barbaro

20 (right). Antonio Verrio (1639–1707): *Olympian Gods*. 1695–6. Decoration of the Heaven Room, Burghley House, Lincolnshire

lorical, the painted statues something out of a Spanish church in South America. But one is taken by the sophisticated conception of the ensemble, the skilful trompe-l'oeil perspective of arches and pillars, between which emerge the crowds converging towards the centre, and by the way these beautifully painted human images progressively become lifelike three-dimensional figures through a point at which some of the personages are half-painted and half-sculpted. If the sculptures are very close in style to those of Ferrari, the painted part of these chapels is the work of a more talented artist who has no difficulty in rendering

volume, instilling life and applying the art of perspective. Indeed, Tanzio's murals are more impressive works of art than most of his oil-paintings. These dramatic religious settings in fact became popular and by the eighteenth century had spread to Switzerland, Germany, other central European countries, and also Brazil.

The influence of the Italian Baroque school was strong throughout the Catholic countries, particularly in France and Austria. In Spain, Valdes Leal produced similar works. While northern artists travelled to Italy to complete their artistic training, Italian artists travelled

28

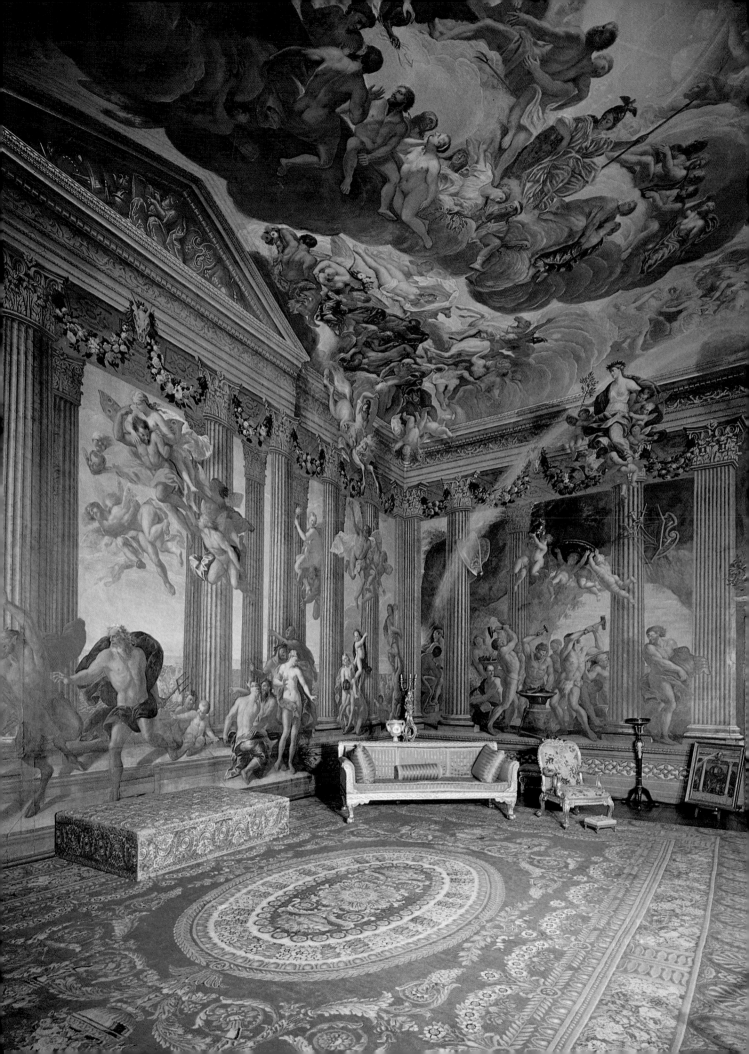

north, seeking patrons. Antonio Verrio (1630–1707), though not a major painter, belonged to the French Academy and came to England, where he was in great demand. He decorated walls at Windsor, Chatsworth, Burghley House (Plate 20) and Hampton Court and succeeded Lely as court painter.

The Baroque style appealed to the French and was fit to enhance the prestige of the Sun King, Louis XIV, and his courtiers. Louis XIV was a formidable personality and with egotistic passion built up a life-style—purely restricted to his court of about 3,000—of incomparable grandeur. The rigidly strict protocol was reminiscent of that of the Chinese emperors. Courtiers flocked to Versailles to obtain favours from the all-powerful monarch and preferred the exiguity of attic rooms in the palace to the comfort of their own—being exiled to one's estates was a dreaded punishment. The best available artists were called to the king's service and Louis XIV's prestige most impressed the foreign rulers. The splendour of Versailles—built between 1660 and 1680—was emulated abroad, but to rival it was quite out of the question. All these buildings, particularly those of Austria and southern Germany, were erected by kings and princes eager to place themselves far above ordinary men. Theirs was a splendidly artificial world, organized like a stage production, much in imitation of the French court. The Italian style of murals, incorporating trompe-l'oeil elements to accentuate a theatrical effect, appealed to them quite naturally (Plate 24).

Although the French commissioned works from Italian painters, they had enough talents of their own to produce excellent examples of Baroque painting. Charles Le Brun (1619–90) was probably the most famous as well as the most prolific. Like many European artists, Le Brun had spent some time in Rome to study and absorb the Italian masters, who

were still ahead of their contemporaries. In Italy, trompe-l'oeil was then only used to reinforce the theatrical character of the murals. Theatre and opera were indeed in great vogue. Three opera houses were built in Venice between 1637 and 1640, requiring theatrical machinery and sets in which trompe-l'oeil was often used. Artists like Annibale Carracci, Bernini and Pietro da Cortona not only designated sets but also directed plays. The fashion spread abroad rapidly and by the eighteenth century, in many princely palaces the theatre had become as essential as the chapel.

With the exception of the great reception rooms of Versailles, the French interiors usually retained a degree of intimacy. More temperate by nature than the Italians, the French preferred their residences to be of human proportions. They also liked gracious *art de vivre*. At the château of Vaux le Vicomte (Plate 21), for example, Le Brun seems to have taken his inspiration from different Italian sources: there are elements of Mantegna's and Bramante's work as well as more contemporary Baroque themes, particularly in the paintings of the ceilings. These he chose to fragment rather than cover whole in more grandiose fashion. It is a place to live in in style rather than in ostentation and, at least in parts, trompe-l'oeil is used effectively, often to simulate natural materials, stone or wood, for example. Not usually given to extremes, the French absorbed the Italian influence but practised it with restraint.

By the mid-seventeenth century, the middle classes had assumed an important role in society. The nobility, the great landowners, would not have anything to do with merchants

21. Charles Le Brun (1619–90): Decoration of the Salle des Buffets, Château de Vaux le Vicomte, France

30

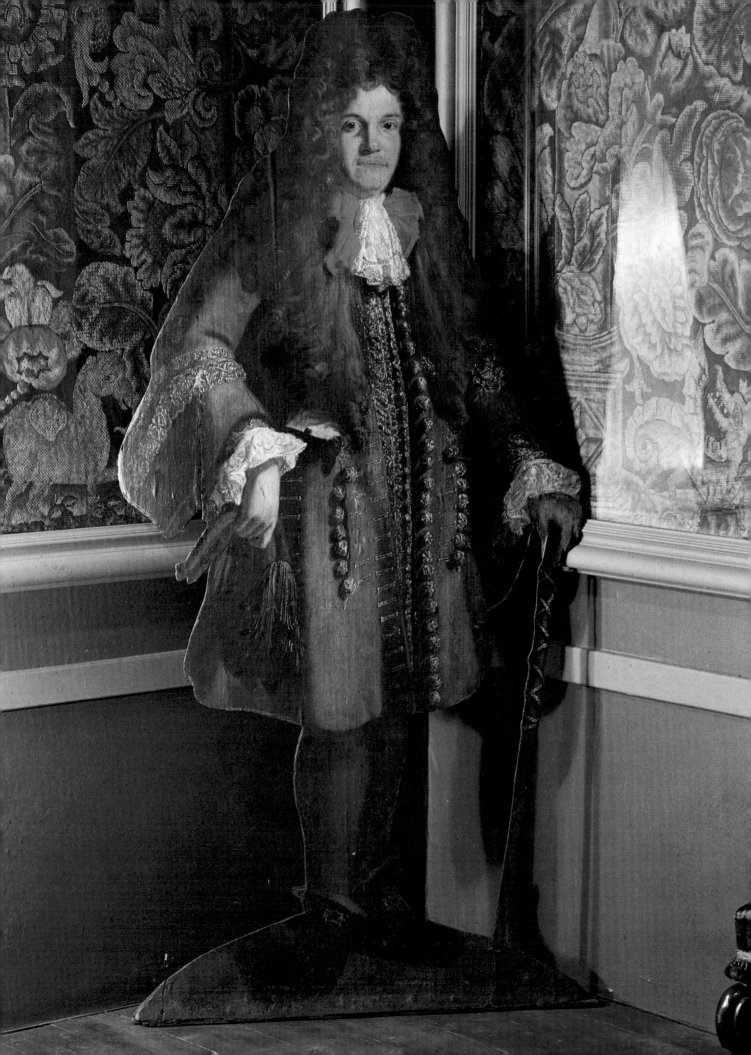

and professional men, but the latter were extremely active and enterprising. If they could not afford to live in luxury, they at least lived in great comfort, often surrounded by works of art, albeit by minor painters. Their furnishing included items of purely decorative domesticity, such as cut-out figures (*chantournés*) representing the masters of the house (Plate 22), their servants, symbolic personages or even animals. These figures were usually life-size trompe-l'oeil. Originating in Holland, they became very popular in the seventeenth century. Trompe-l'oeil was a favourite genre of the middle classes and would remain so, as it is an essentially materialistic genre.

In the seventeenth century, the best examples of trompe-l'oeil painting were coming from the north of Europe, Holland particularly. Holland was a country of Protestant merchants—practical, money-conscious and powerful men who intensely disliked pomp, artifice and fanciful flights of imagination. The Baroque style was certainly not to their taste; they were much more inclined to the domestic scenes, landscapes, portraits and still-lifes that artists produced in response to their taste. It was the time of Frans Hals (1580?–1666), Rembrandt (1606–69), Ruisdael (1628?–82) and Vermeer (1632–75). Among the Dutch craftsmen who produced oil-painted trompe-l'oeil on wood or canvas, the Gysbrechts were the most accomplished. Many artists painted trompe-l'oeil only occasionally, but the Gysbrechts devoted most of their efforts to it. Little is known of Cornelius Gysbrechts. He was born in Antwerp, probably during the first decade of the seventeenth century, and joined the Guild of St Luke in 1659. In 1668, he appeared in Copenhagen and was em-

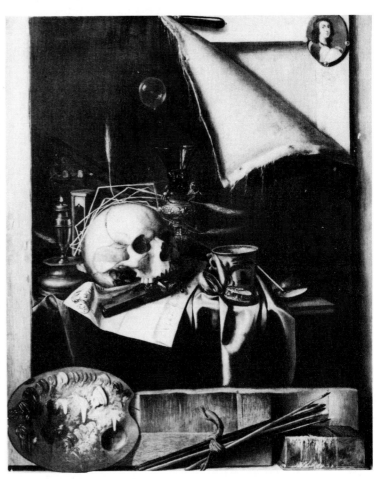

23. Cornelis-Norbertus Gysbrechts (active c.1659–78): *Vanitas*. Oil on canvas, 87.3 × 70.5 cm. (34⅜ × 27¾ in.) Kingston upon Hull, Ferens Art Gallery

ployed by the kings of Denmark, Frederik III and Christian V. His latest known work is dated 1675; thereafter, there is no trace of him. Franciscus Gysbrechts was perhaps related to Cornelis—their works are certainly very similar—but we know practically nothing of his life, except that he may have entered the same Guild of St Luke in 1676.

Their output amounts to about 100 paintings, which are important in their own right, but even more as archetypes of trompe-l'oeil technique, exploring nearly all the possibilities of the genre and remaining influential even today. They painted wood-like backgrounds or wooden frames, small cupboards with closed or half-open glass-panelled doors and a great number of *Vanitas* paintings (Plate 23). This was a typical subject of the

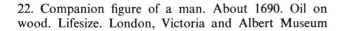

22. Companion figure of a man. About 1690. Oil on wood. Lifesize. London, Victoria and Albert Museum

period, meant to remind the viewer of the futility of material possessions and the inevitable passing of time, frequently illustrated by hour-glasses. Instead of simply depicting the subject on the whole surface in the customary manner, the Gysbrechts often represented the canvas itself as deteriorating, partly detached from the frame, which hung from a wood panel on which other objects were nailed—small portraits, an artist's palette and brushes, small pieces of paper. They also rendered curtains partly drawn to reveal letter racks filled with papers in sheets or bundles and various small objects (Plate 25). Curtains were commonly used at the time to protect valued paintings from the light and dust and were therefore good trompe-l'oeil motifs. The Gysbrechts painted canvases in reverse—one of the least likely subjects but one of the most effective visual illusions, and a rather surrealistic conception. Cornelis Gysbrechts also made *chantourné* trompe-l'oeil—not figures, but a clever arrangement of easel and canvases (Plate 26), or else *vide-poches* filled with an array of objects. The surface is absolutely flat but so well treated that the make-believe is perfect. He was of course a skilful still-life painter and some of his trompe-l'oeil paintings are close to this genre, though the intention to deceive is always present, with objects hanging from wood panels, arms, musical instruments, hunting gear, and suchlike. However, it should be noted that the Gysbrechts did not invent all the devices they used. The first known wood background, for instance, was painted by Jacopo de' Barbari in 1504. Letter racks had already been done, notably in 1658 by Wallerant Vaillant, a northern Frenchman who had lived in Amsterdam.

24. Giovanni-Battista Carlone (1592-1677): Decorated ceiling. Fresco. Château de Cagnes, France

34

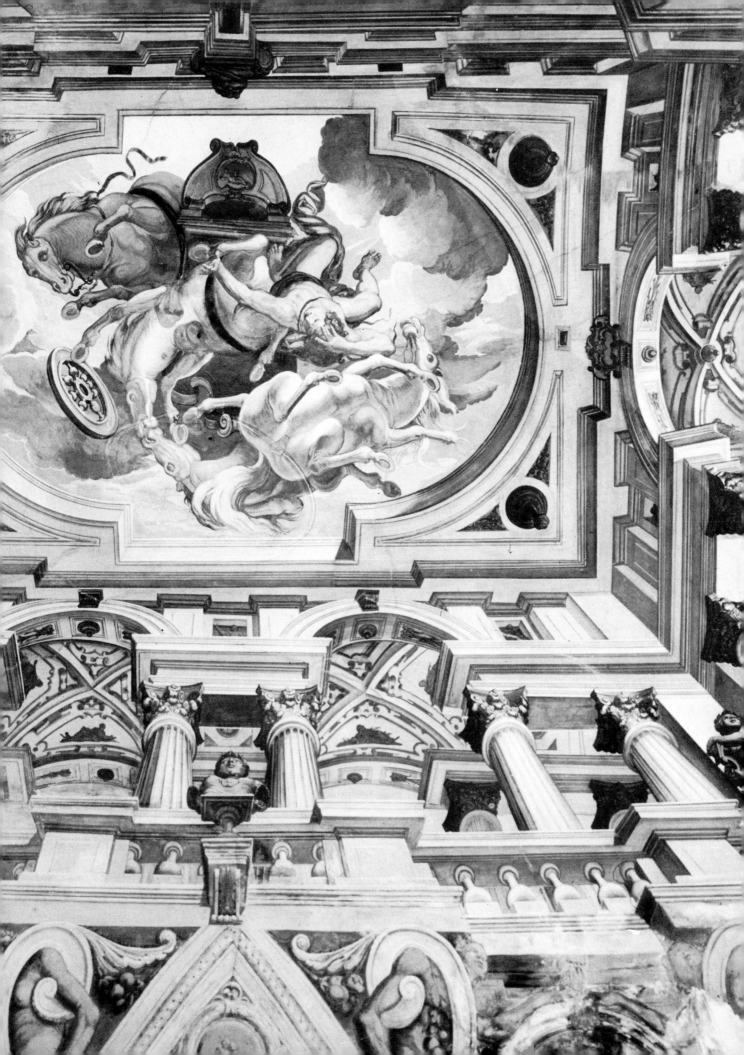

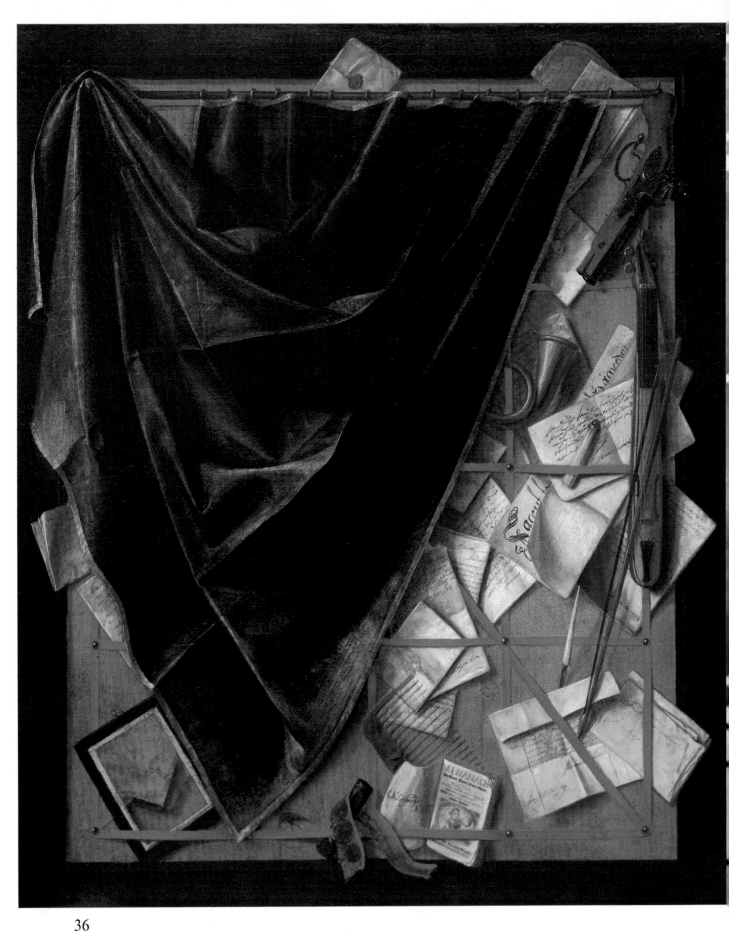

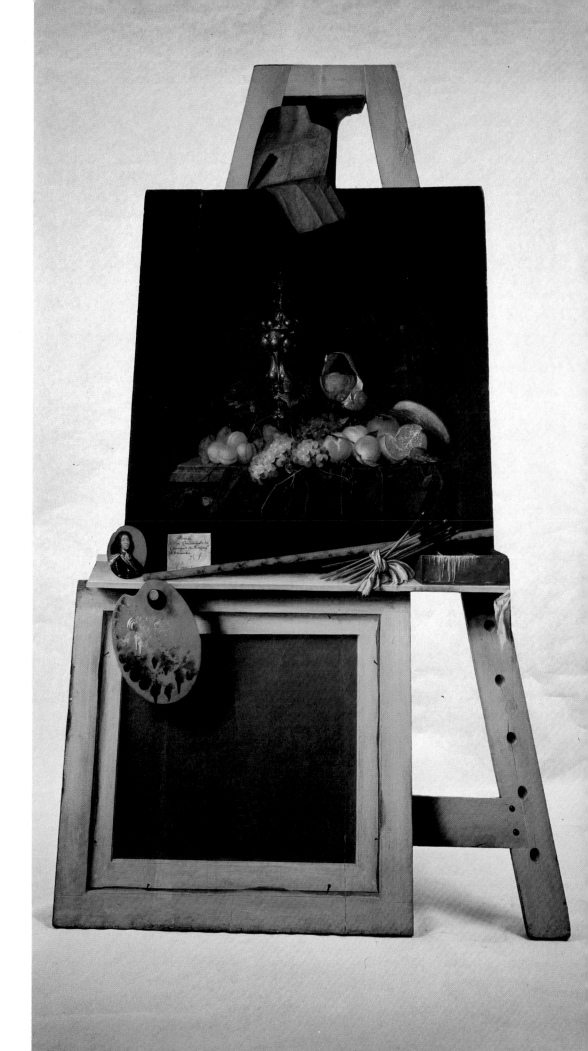

25 (left).
Cornelis-
Norbertus
Gysbrechts
(active c.1659–78):
*Letter Rack and
Curtain*. Oil on
canvas, 101 ×
83 cm. (39¾ ×
32¾ in.) Ghent,
Museum of Fine
Arts

26 (right).
Cornelis-
Norbertus
Gysbrechts
(active c.1659–78):
Painter's Easel.
Oil on canvas,
226 × 123 cm.
(89 × 48⅜ in.)
Copenhagen,
National
Museum of Art

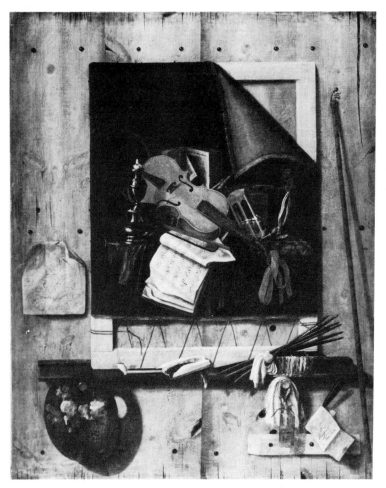

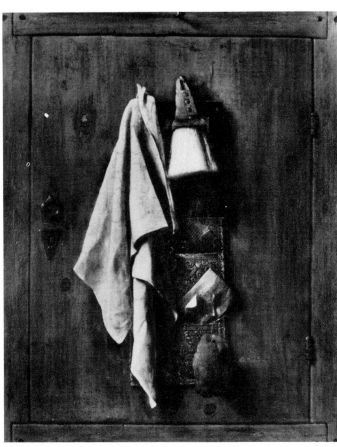

27. Alexandre-François Desportes (1661–1743): *Painter's Materials.* Oil on canvas, 130 × 105 cm. (51¼ × 41⅜ in.) Valenciennes, Musée des Beaux Arts

28. Samuel van Hoogstraten (1627–78): *Still-Life.* 1655. Oil on canvas, 72 × 92.5 cm. (28⅜ × 36⅜ in.) Vienna, Akademie der bildenden Künste

Letter racks, objects and slightly worn engravings pinned or sealed on to wooden boards were very popular during the second half of the seventeenth century. They were mostly the work of Dutch artists (perhaps the Dutch enjoyed the contrast between a slightly unkempt-looking trompe-l'oeil and their immaculate interiors?). But French, British and Spanish painters produced some as well and one can see why they appealed to the middle classes, who must have appreciated their craftsmanship and unpretentious domesticity (Plates 27–31). They must also have liked their slightly eccentric humour. Other artists of the late seventeenth century combined trompe-l'oeil with optics and produced peep-shows. The viewer would look through a small opening into a box and see very good illusionistic interiors. They are not essentially trompe-l'oeil, because the scale of such rooms is much reduced and also because they involve elements of anamorphosis which have nothing to do with trompe-l'oeil. Anamorphosis consists in painting a distorted subject that will be restored to its normal shape when seen from a certain angle. Typical were circular portraits that could be seen properly when reflected in a cylindrical metallic mirror. Samuel van Hoogstraten, who created such a box in about 1660 (now in the National Gallery, London), also painted the remarkable *View Down a Corridor* (Plate 32).

38

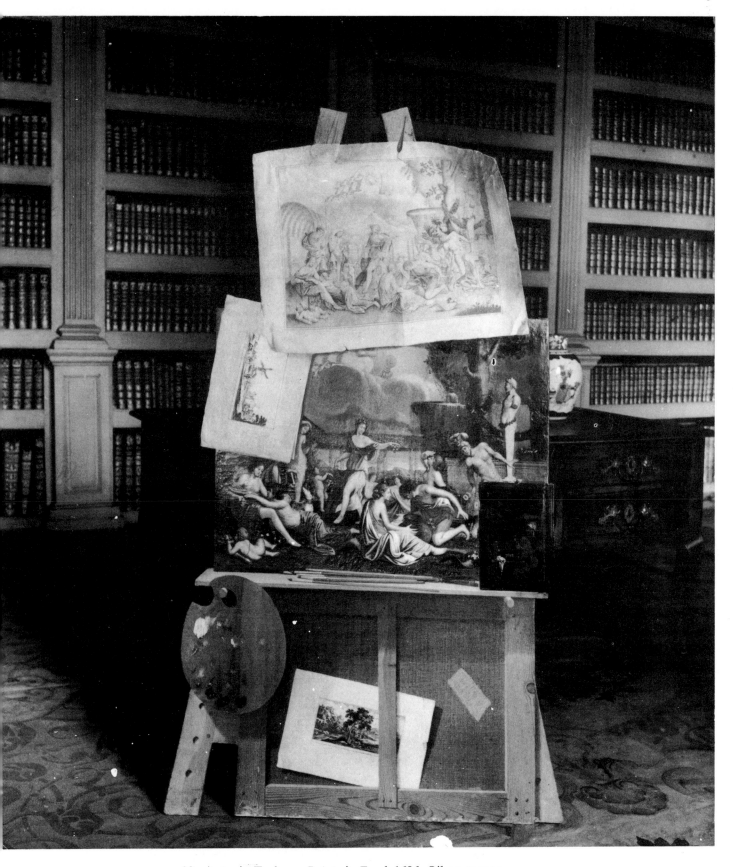

29. Antonio Forbera: *Painter's Easel*. 1686. Oil on canvas
162 × 95 cm. (63¾ × 37½ in.) Avignon, Musée Calvet.

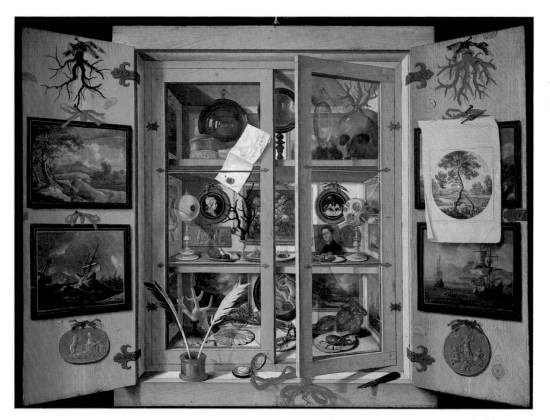

30. Anonymous: *Cabinet of Curiosities*. Late 17th century. Oil on canvas, Florence, Opificio delle Pietre Dure

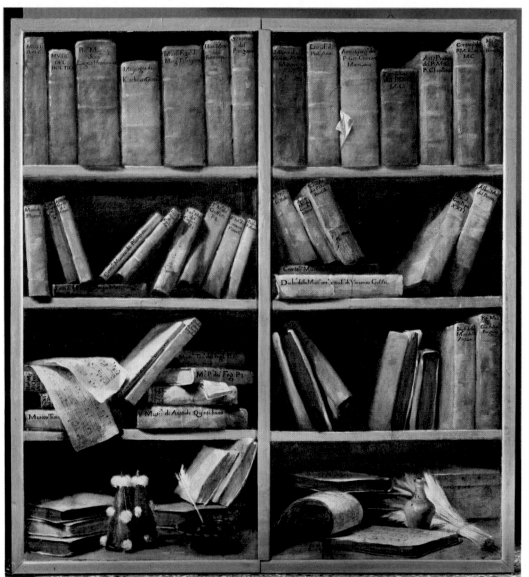

31. Giuseppe Maria Crespi (1665–1747): *Shelves with Music Books*. About 1710. Oil on canvas. Bologna, Conservatorio Musicale 'G.B. Martini'

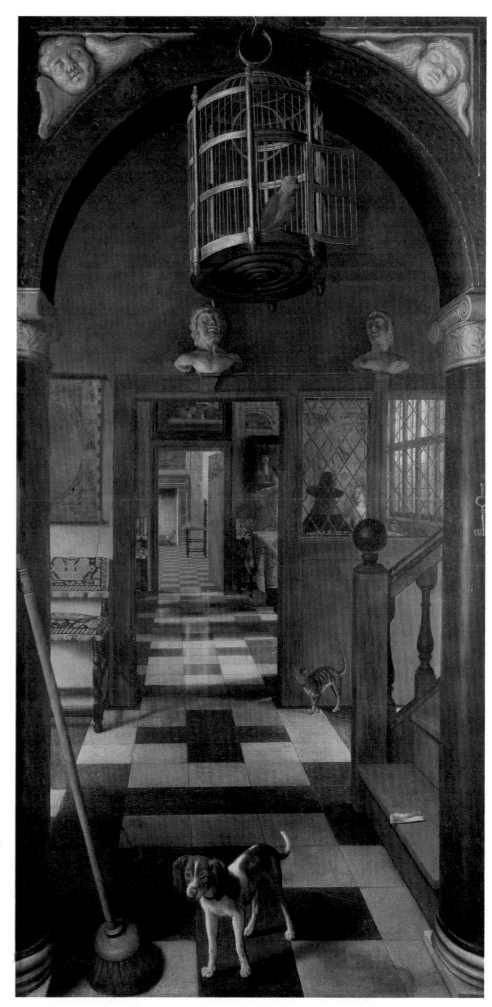

32. Samuel van Hoogstraten
(1627–78): *View down a Corridor*.
1662. Oil on canvas. Dyrham Park,
near Bath, England

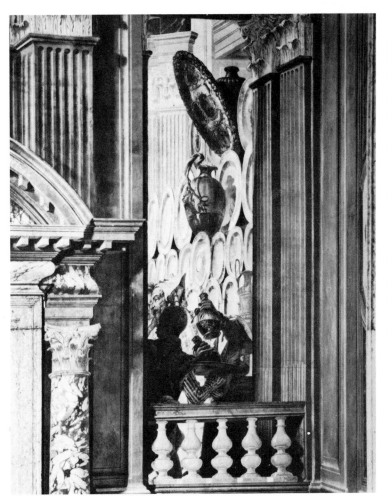

The eighteenth century saw the Italians continue the Baroque tradition to the point of losing themselves in fantastic excesses of ornamental decoration. Grandiose, extravagant buildings and murals were still the fashion, best illustrated in the works of Tiepolo (1696–1770), the last major name of the great Italian age, now in its decline. He was from Venice, had been a pupil of Ricci, Piazzetta and Veronese and had married Francesco Guardi's sister. Tiepolo included trompe-l'oeil in many of his murals, the best-known being those at the Palazzo Labia in Venice (Plates 33, 34). His style was graceful and lively, his colours bright and yet soft, his figures clad in a mixture of contemporary and pseudo-classical dress. There is precious little trace in his work of the exalted emotional spirit of the high Baroque. Essentially decorative, it exemplifies the style called Rococo which lasted well into the middle of the eighteenth century.

The Italian influence was as usual strongest in Austria and southern Germany, where stucco and decorations were used with untempered extravagance (Plate 35). Tiepolo, as well as many other Italian painters and architects, produced a number of works in these countries, where the Rococo style was more popular than anywhere else. The French took it up as well, though to a lesser extent. They liked its purely decorative, feminine prettiness. Watteau (1684–1721) is a good example of the French taste for frivolity. He designed interior decorations before devoting his time to painting, and his charming canvases show well the degree of dreamy unreality in which the upper classes had secluded themselves. Another example is the

33. Giovanni Battista Tiepolo (1696–1770): *Servants on the Balustrade*. 1745–50. Fresco. Venice, Palazzo Labia

34. Giovanni Battista Tiepolo (1696–1770): *Cleopatra's Banquet*. 1745–50. Fresco. Venice, Palazzo Labia

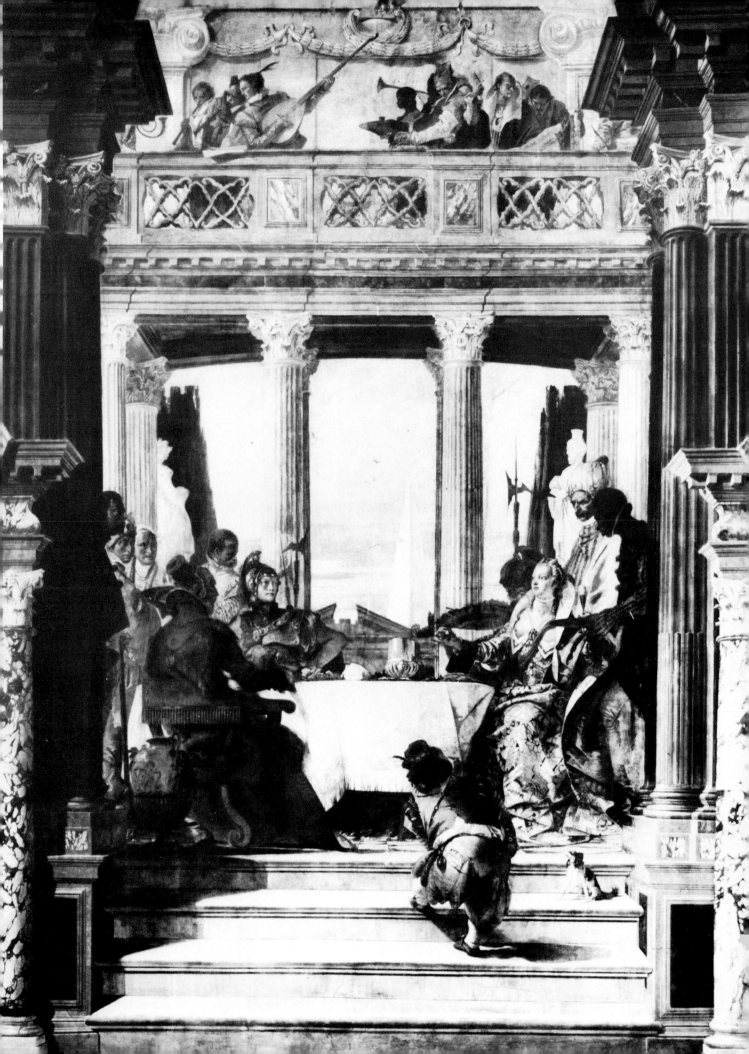

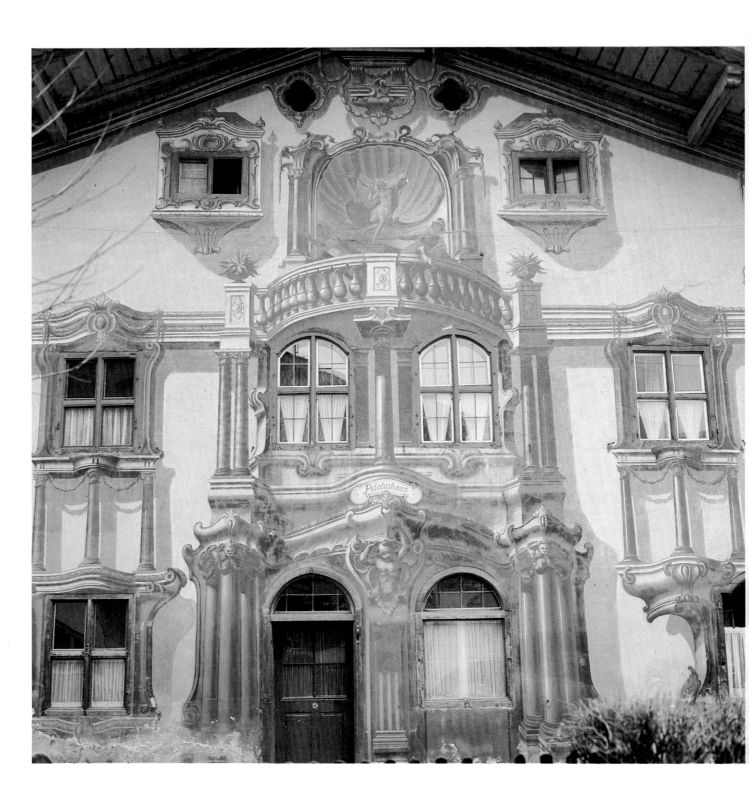

35. F. S. Zwinck: Façade of a house in Bavaria. 18th century.

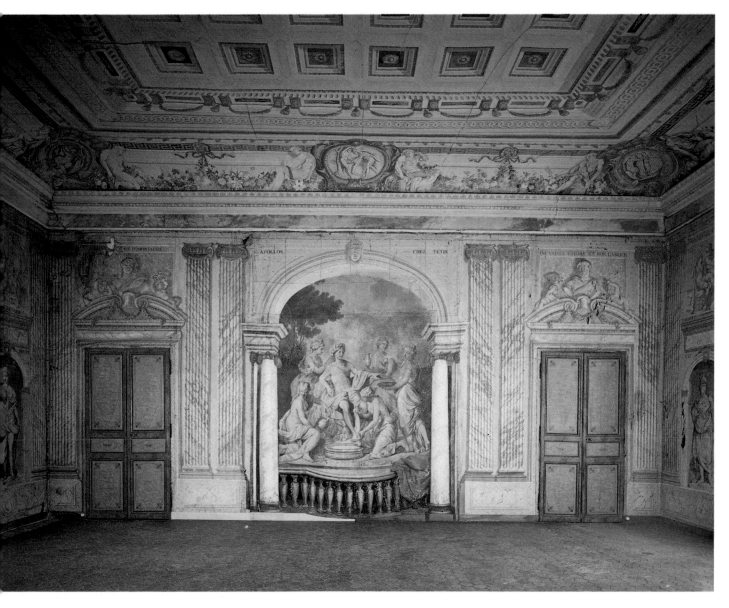

36. Jean-Nicolas Servandoni (1695–1766) and Jean-Baptiste Oudry (1686–1755): *Apollo and Thetis*. c.1721.
Wall decoration in the Château de Condé en Brie, France

castle of Condé en Brie (Plate 36), entirely painted in trompe-l'oeil decorations in the 1720s by Servandoni, Louis XV's architect, and Oudry (1686–1755). The whole decoration reminds us of a theatrical setting. Trompe-l'oeil was mainly used by the upper classes in wall decorations; the middle classes bought it as paintings to hang on their walls. But there were exceptions. Louis XV of France, who was very fond of hunting, wished to preserve a record of certain freak stag antlers. Oudry was commissioned to paint them and used trompe-l'oeil so effectively as to transform a most unappealing subject into interesting works of art (Plate 41). Many trophies of this period were painted in that way (Plates 39,40).

45

Intarsia was used in furniture, but on the whole there are very few examples of eighteenth-century trompe-l'oeil—mainly found in Holland and Germany (Plate 38). This was not the right time for the straight lines of perspective, and floral motifs were more in favour. Hard stones had been used from time to time since the Renaissance to decorate the tops of tables and consoles with either geometric or floral patterns. The few attempts at trompe-l'oeil were not very convincing, the best perhaps being a set of eight consoles in the Prado, some of them decorated with

fanciful landscapes in perspective. But to achieve a good illusionistic effect with stones must be nearly impossible because of the limited range of nuances and also because the sharp edge of each shape is too obvious. In the eighteenth century, we still find letter racks (Plate 37), *chantournés* and *Vanitas* paintings, but bourgeois trompe-l'oeil extended to more domestic objects. There was a vogue for *devants de cheminée*, which were not fire screens but panels that masked the aperture of fire-places when not in use. Sometimes still-lifes were employed, and these were often

37 (below). Edward Collier (d. c.1702): *Trompe-l'Oeil with Writing Materials.* 1701. Oil on canvas, 47 × 64.8 cm. (18½ × 25½ in.) London, Victoria and Albert Museum

38 (right). German secretary book-case. About 1740. Intarsia, 215 × 105 × 60 cm. (85 × 41 × 24 in.) Kansas City, Atkins Museum of Fine Art, Gift of Mrs Kenneth A. Spencer

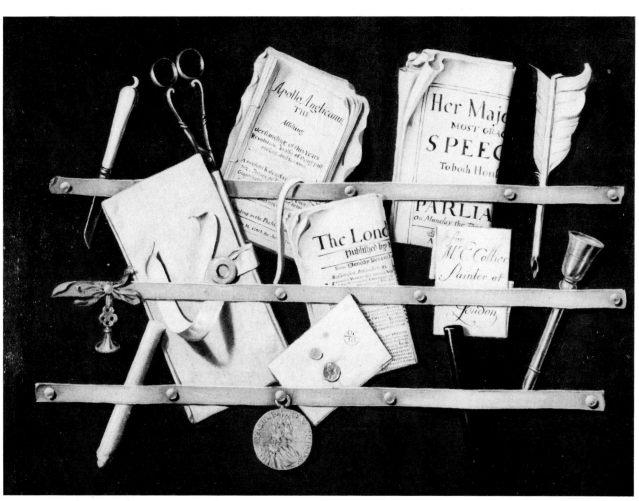

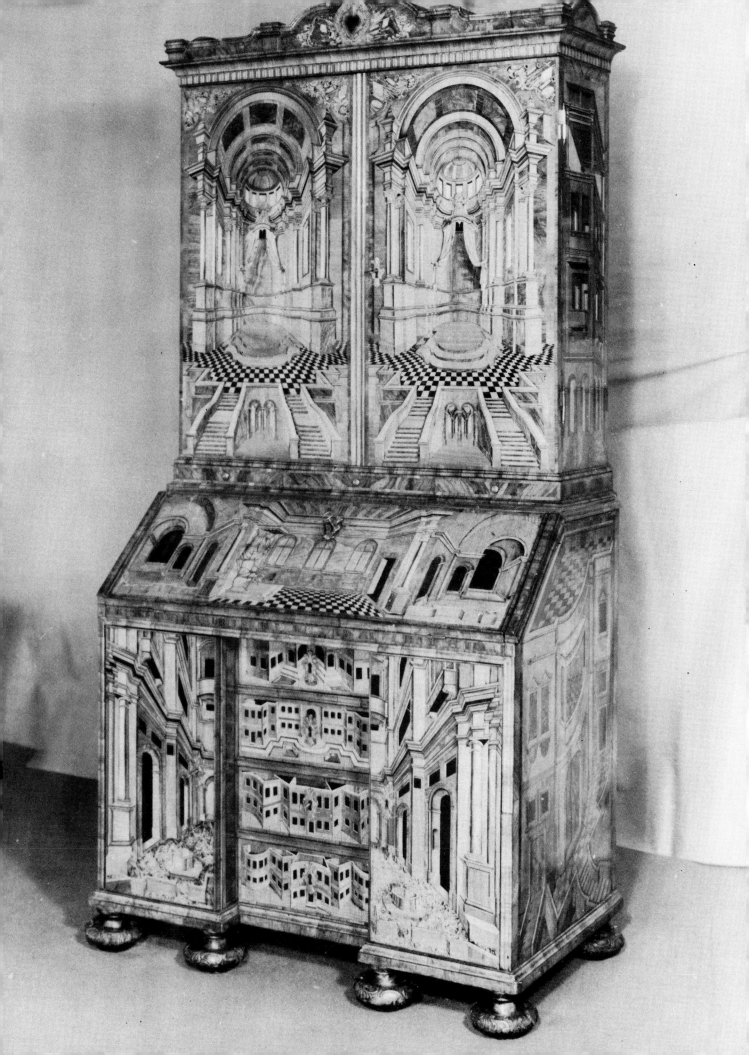

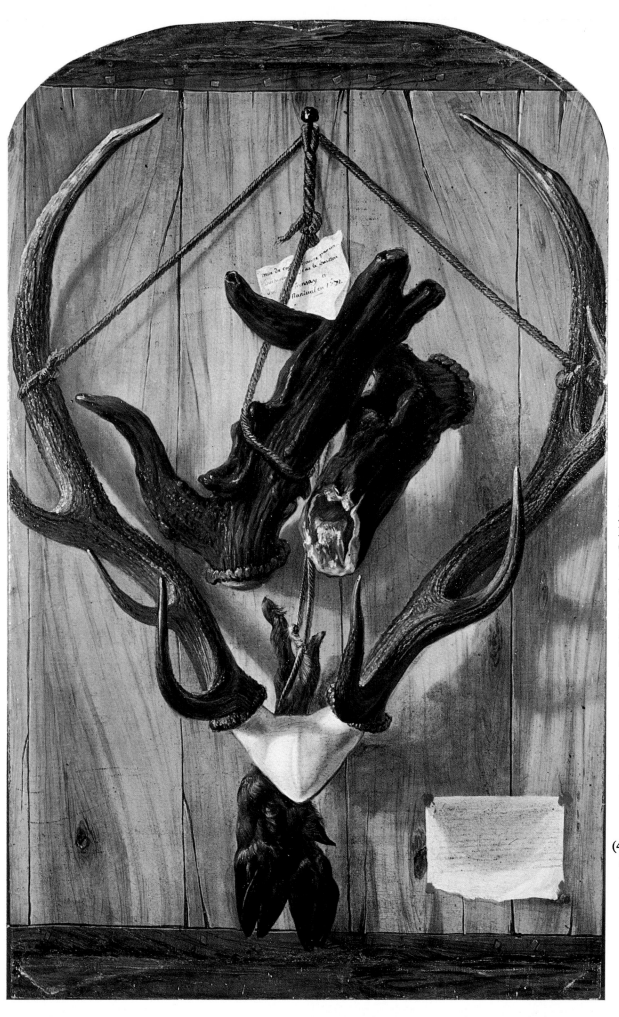

39 (left).
Jean-François
Perdrix
(c.1746–
1809):
Antlers. Oil
on canvas,
110 × 70 cm.
(43¼ ×
27½ in.)
Paris, Musée
de Chantilly

40 (right).
Alexandre-
Isidore Leroy
de Barde
(1777–1828):
*Collection of
Foreign Birds*.
1810.
Watercolour
and gouache,
126 × 90 cm.
(49½ × 35½ in.)
Paris, Louvre,
Cabinet des
Dessins

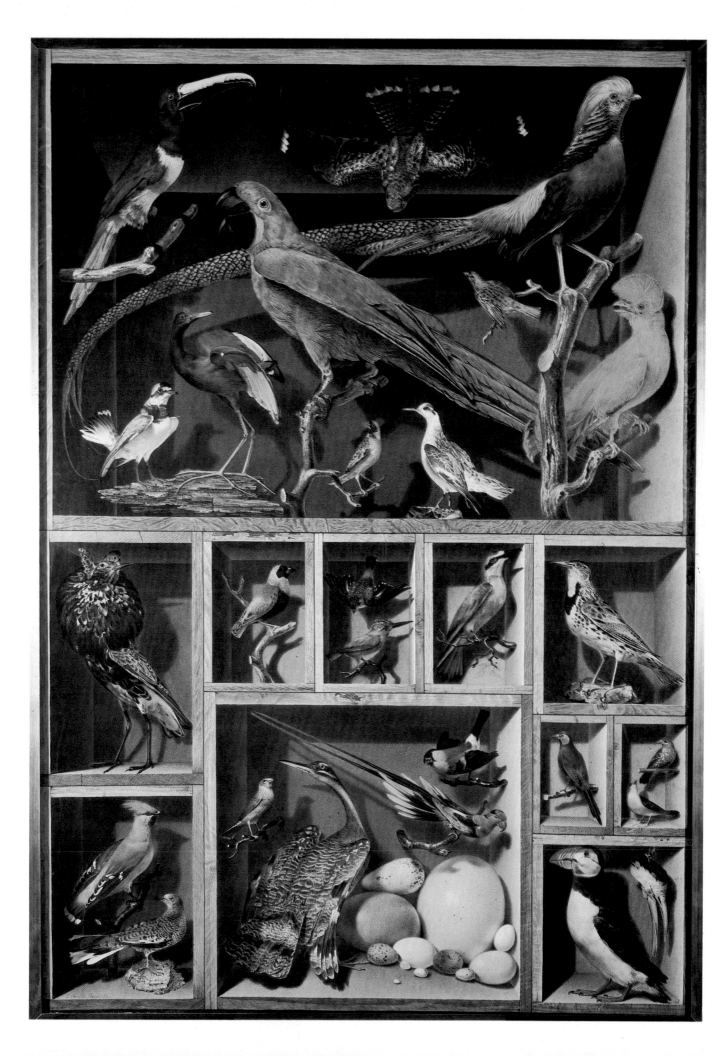

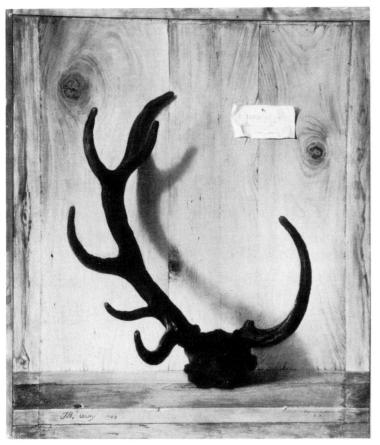

meant to be trompe-l'oeil representing domestic animals, vases of flowers or books and objects piled up and occasionally set on a table or a chair. However, they fail to strike us as illusionistic enough. Plates and dishes were also decorated with trompe-l'oeil motifs (Plate 43). On the whole, the middle classes reacted to the frivolousness of Rococo by turning their attention to the beauty found in the daily life of ordinary people, in a manner reminiscent of the Dutch. Chardin (1699–1779) was the embodiment of such reaction in France and we find a similar tendency in England, though for quite different reasons.

The only English decorator in the Baroque tradition was James Thornhill (1675–1734). He had been influenced by Verrio but was a better artist, and produced a number of murals such as *The Golden Age of George I* at Greenwich Hospital and the ceiling of Queen Anne's bedroom at Hampton Court (Plate 42). He also decorated the dome of St Paul's cathedral built by Christopher Wren between 1675 and 1710 and was, incidentally, Hogarth's father-in-law.

In England, the Puritan influence had inhibited the development of the arts. Consequently, by the eighteenth century, though Puritanism had lost much of its strength and patrons were not opposed to a certain amount of decoration, there were few British artists able to satisfy their demands. Furthermore, it had become fashionable for young upper-class men to complete their education by touring Europe, particularly Italy, and as a result patrons preferred to import Italian artists rather than encourage local talents. Claude Lorrain, with his well-composed classical Italian landscapes, remained one of the most

41. Jean-Baptiste Oudry (1686–1755): *Head of a Stag taken by the King in the Forest of Compiègne*. 1749. Oil on canvas. Paris, Musée de Fontainebleau

42. James Thornhill (1675–1734): Ceiling of Queen Anne's bedroom. 1715. London, Hampton Court Palace

43. J. Deutsch: Plate. 18th century (Niderviller).
London, Victoria and Albert Museum

highly-praised artists. This situation angered British artists like Hogarth (1697–1764) and they reacted by painting scenes of life as they saw it—although their tone is much more sarcastic than that of the Continentals. With Hogarth, followed by Reynolds (1723–92) and Gainsborough (1727–88), British painting emerged from a long limbo and subsequently produced many talented and original artists.

Nature was 'discovered' during the second half of the eighteenth century, mainly owing to the influence of the French philosopher Jean-Jacques Rousseau. She penetrated the lives of the upper classes on murals in small recreational buildings such as summer or music pavilions built in the parks of private estates. Here, trompe-l'oeil colonnades and banisters would be placed against a background of shrubs and trees—attractive decorations, but not very convincing, as nature, like all other live subjects, does not make good trompe-l'oeil. Grisaille was more effective and continued to be popular (Plate 44). Traditional trompe-l'oeil using wood panelling was still in demand, but the vogue was for paper, perhaps because it had become a widespread commodity. We find paintings simulating messages pinned haphazardly on boards, half-torn political manifestoes or overlapping sketches, blank sheets and engravings. Boilly (1761–1845), who painted many trompe-l'oeil, did some excellent ones in this mode (Plate 46).

52

Another popular genre was paintings or engravings seen as if behind broken glass, the picture represented being generally a pretty girl in the manner of Boucher. The subject was undoubtedly chosen on purpose: the lovely lady is threatened by the jagged edge of the glass—and her possible disfigurement certainly evoked a shudder from the beholder.

The aristocratic life-style suffered much from the Revolution of 1789, and the bourgeoisie triumphed, as can easily be observed in contemporary portraits. A conservative society emerged in France, avid for respectability and order, even at the price of boredom, and it was no longer amused by the humour of trompe-l'oeil. There are, therefore, few to be found in nineteenth-century Europe, except as printed wallpaper of remarkable quality, made for a wealthy clientèle (Plate 45). In line with the Neo-classical vogue of the Napoleonic era, best illustrated by David's paintings, this paper simulated the soft folds of drapes hung along the walls and was very effective, while being far less expensive than fabric. This fashion lasted until the end of the century. By then, the drape effects had been replaced by floral garlands, bouquets, simulated urns, statuary and banisters, which were vaguely reminiscent of the eighteenth century—it had returned into fashion—though the nineteenth-century productions are unmistakably less witty and less elegant.

Another kind of trompe-l'oeil appeared during the late nineteenth century and would last into the first decades of the twentieth. The result of industrialization was mass production, which led to fierce competition between businesses. There was a need for effective advertising, mainly aimed at the working and lower middle classes, and manufacturers thought of promoting their goods not only by posters, but also with objects of popular appeal that could be more or less mass-produced. Biscuit boxes (Plate 47), for

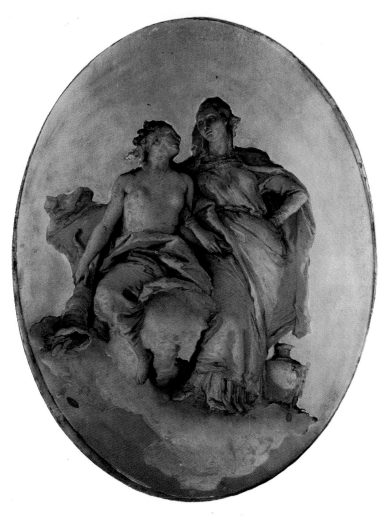

44. Giovanni Battista Tiepolo (1697–1770): *An Allegory of Temperance and Plenty.* Present whereabouts unknown

53

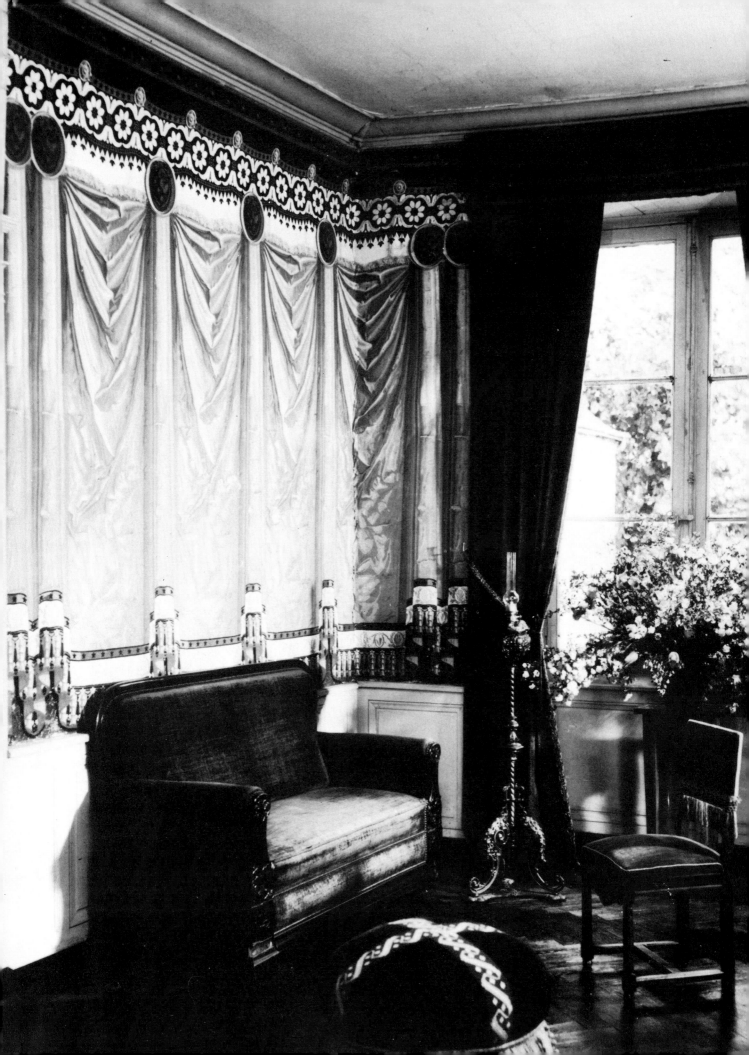

instance, were made to look like real piles of biscuits. Some of these objects were made as well for the sheer pleasure of innocent deception and were attractive to people of simple tastes and means who could not afford any expensive *objets d'art*. We find fried eggs in small dishes (Plate 49), napkins folded in their rings, baskets of fruit (Plate 50), piles of plates, and suchlike. Bernard de Palissy's dishes laden with fish were rediscovered as part of the nineteenth-century interest in the Middle Ages (Plate 48), and inspiration came also from the pretty eighteenth-century porcelain flowers, figurines and trompe-l'oeil plates.

45 (left). Trompe-l'oeil wallpaper. Early 19th century. Château de Saché, Val de Loire, France

46 (below). Léopold Boilly (1761–1845): *Trompe-l'Oeil.* Late 18th century. Present whereabouts unknown

55

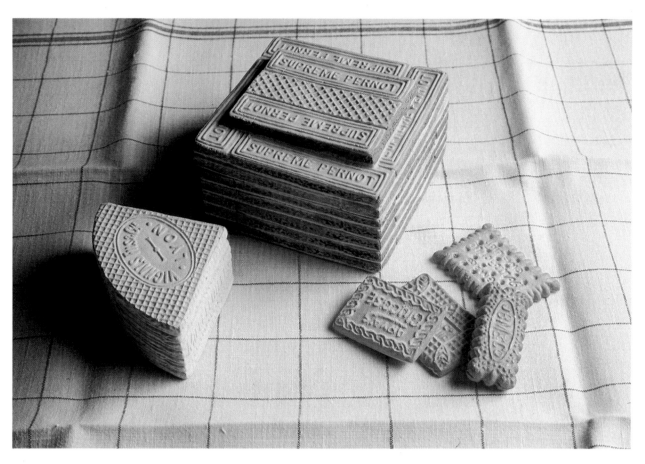

47. Biscuit boxes. 19th century. Ceramic. Paris, Collection Dina Vierny

48. Fish plate. 19th century. Paris, private collection

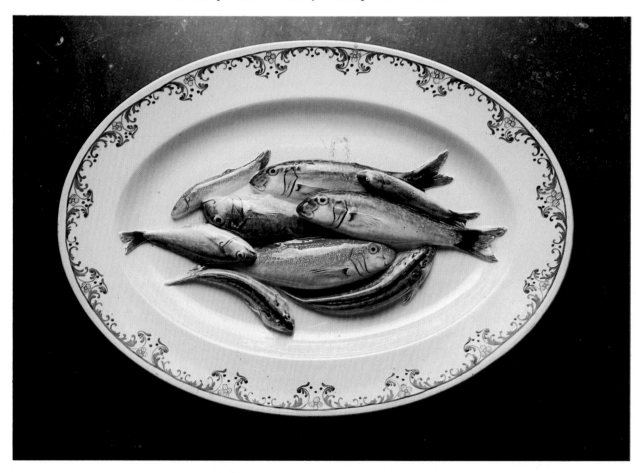

49. Fried eggs. 19th century. Ceramic. Paris, Collection 'Au Beau Noir'

50. Basket of fruit. 19th century. Ceramic. Paris, Collection 'Au Beau Noir'

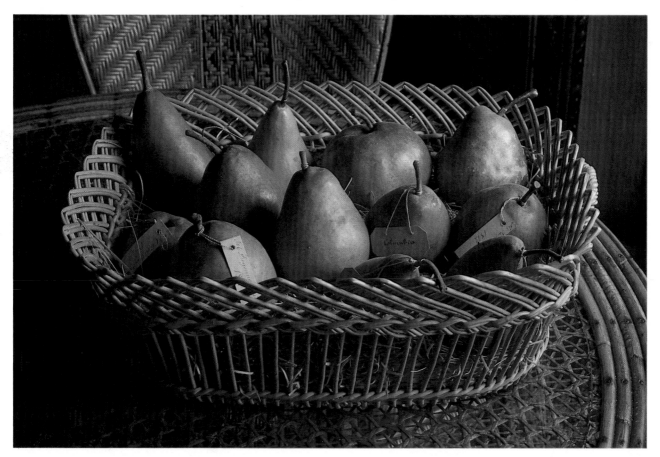

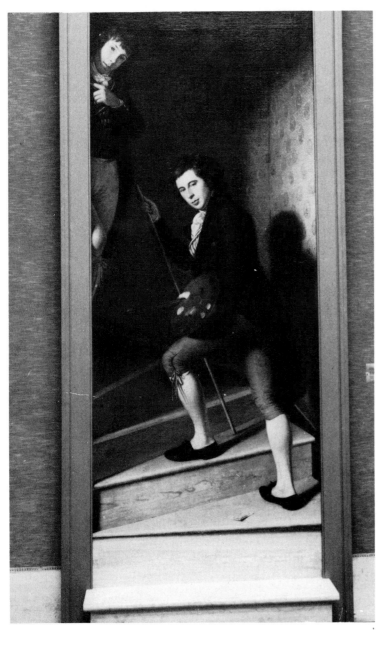

These charming objects, no longer manufactured, have retained their illusionistic power and have naturally become collector's items.

After the Revolution of 1776, America was establishing its new independence and developing a national identity. During the eighteenth century, a large proportion of American citizens were still European *émigrés* who had brought with them elements of their original cultures. The better-off were in farming and trade and there was no room for aristocratic frivolity among this hard-working community. These people were chiefly interested in portraits, and the works produced are of greater historical than artistic value, since the painters were often self-taught craftsmen rather than accomplished artists. But some of them, like Copley (1738–1815), the greatest of all 'colonial' artists, went to England to study and remained in close contact with Europe. However, they were bound to evolve quite independently, as they had no local tradition to support them. Copley did in fact settle in Europe in 1774 and joined the Neoclassical and later Romantic movements that followed the French Revolution. Before Charles Wilson Peale (1741–1827), there are very few examples of American trompe-l'oeil. Lacking sufficient technique, the painters' attempts in this field are as naïve as are their portraits. Peale is considered the last of the colonial painters. He was a saddler and a woodcarver, an energetic man of great curiosity who was interested in science as well as art. He learnt painting from Copley and went to London between 1767 and 1769 to study under Benjamin West. Back home in Philadelphia, Peale did many portraits, founded the first American museum of Natural History, started an art gallery and was instrumental in the creation of the Pennsylvania Academy of Fine Arts.

Academies were a relatively new feature of artistic life. There, students were encouraged to work under government patronage rather

51. Charles Willson Peale (1741–1827): *Staircase Group.* About 1795. Oil on canvas, 226 × 100 cm. (89 × 39½ in.) Philadelphia, Museum of Art

58

than in the studio of one particular master. Their rise indicates how officialdom was progressively replacing private sponsorship. Although a Florentine Academy had been founded in 1563 and one in France in 1648, academies did not assume a major role before the late eighteenth century. The Royal Academy of London was founded in 1768, with Reynolds as president. Their aim was to raise the social status of artists who, however talented and popular, were generally considered second-class citizens and fared little better than actors. Whatever its advantages, academic tuition did not encourage originality and a certain spirit of conformity ensued, which was detrimental, in particular, to the genre of trompe-l'oeil. Such conformity however, had not yet threatened men like Peale and he produced at least one good trompe-l'oeil, the *Staircase Group* (Plate 51), about 1795, using two of his sons, Raphaelle and Titian, as models. Peale was obviously art-obsessed, as most of his seventeen children were given the names of illustrious painters; some of them became painters themselves and Raphaelle signed some excellent trompe-l'oeil, the best known being *After the Bath*, 1823 (Plate 52). Here the rendering of the sheet is very illusionistic, but one feels that the artist has stopped half-way by allowing the arm and foot of the bather to appear from behind the cloth. Raphaelle's sister Margaretta Angelica also painted some trompe-l'oeil of excellent quality.

Americans were destined to keep alive the trompe-l'oeil tradition at a time when Europeans had lost interest in it. Mainly settled in the east, where towns like Philadelphia, Boston and New York were growing centres, they were more provincial, less sophisticated than their European counterparts. Many of them had retained tastes similar to that of their forebears—and for the same reasons. As trompe-l'oeil artists, the Americans tried their

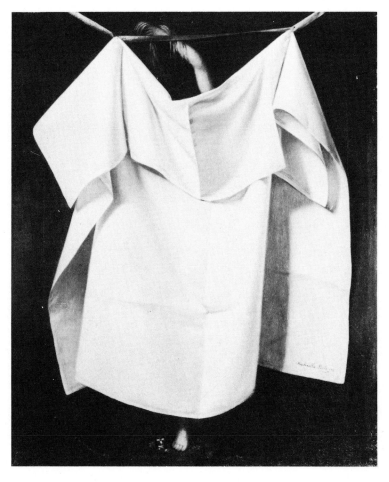

52. Raphaelle Peale (1774–1825): *After the Bath*. 1823. Oil on canvas, 73.7 × 61 cm. (29 × 24 in.) Kansas City, Atkins Museum of Fine Art

59

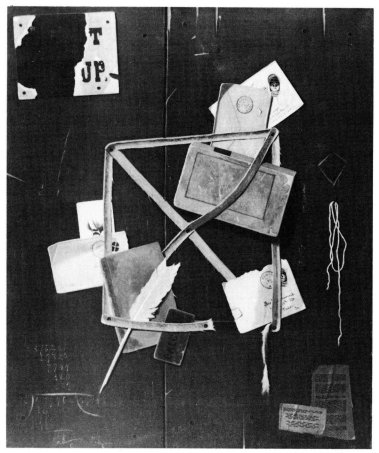

hands at traditional themes: children appearing through half-open doors, grisaille reliefs, the backs of canvases, pictures seen through broken glass, and so on, but without surpassing the European works. By the first quarter of the nineteenth century, there were many skilful American painters, like Charles Bird King (1785–1862), a portrait painter who had studied under Benjamin West and Leslie in London and was also an accomplished trompe-l'oeil artist. Although the style of these painters reminds us of the seventeenth-century Dutch tradition, their works are not servile copies. Their still-life trompe-l'oeil are often like memoranda, full of personal allusions—to their uneasy financial situation, for example.

However, as American life was evolving extremely quickly, interest in trompe-l'oeil waned and did not fully revive until the end of the century. By that time, the Romantic movement was a thing of the past. Industrialization had grown faster in America than anywhere else, profoundly affecting the lives of its citizens. Despite original talents at home, American artists were still looking towards Europe for guidance. There the Impressionists were at their height under Monet's leadership, though Cézanne's influence was to be the most significant for succeeding generations. Photography was timidly developing into a new art-form and was also being used by many artists, including the practitioners of trompe-l'oeil, as reference for their compositions. But Impressionism seemed in its own time too revolutionary to a large public used to conventional realism in works of art. Americans were fond of landscapes and

53. John Frederic Peto (1854–1907): *Old Scraps*. 1894. Oil on canvas, 76.2 × 63.8 cm. (30 × 25⅛ in.) New York, Museum of Modern Art, Gift of Nelson A. Rockefeller

54. William Michael Harnett (1848–92): *After the Hunt*. 1885. Oil on canvas, 180.3 × 121.9 cm. (71 × 48 in.) San Francisco, California Palace of the Legion of Honour, Mildred Anna Williams Collection

60

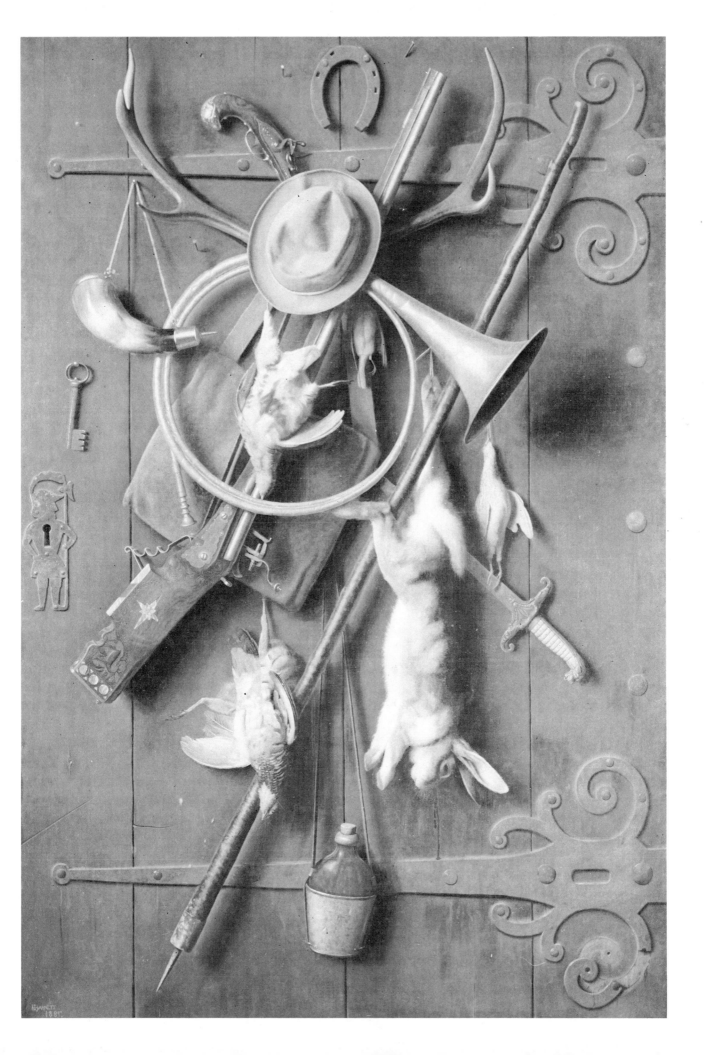

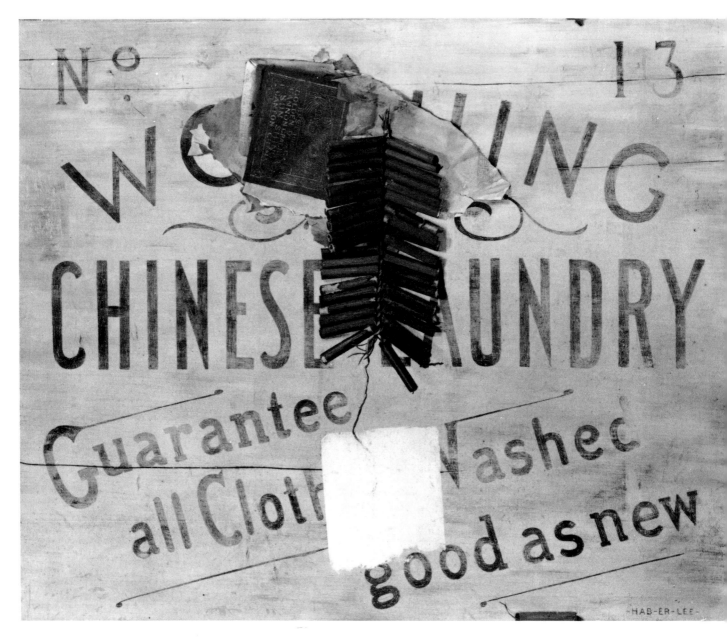

55. John Haberle (1858–1933): *Chinese Firecrackers*. Oil on canvas, 53.7 × 66.5 cm. (21⅛ × 26⅛ in.) Hartford,
Connecticut, Wadsworth Atheneum, The Ella Gallup Summer and Mary Catlin Summer Collection

scenes from daily life—two genres in which
their artists excelled. In view of this domestic
preference, it was not an unlikely moment for
trompe-l'oeil to revive, though it was the
extreme opposite of Impressionism, and
American trompe-l'oeil did emerge force-
fully, its influence becoming as important as
that of the Gysbrechts.

Among many others, three trompe-l'oeil
artists were dominant: W. M. Harnett

(1848–92), J. F. Peto (1854–1907) and
J. Haberle (1858–1933). It is interesting to
compare their dates of birth with those of
their eminent contemporaries: Manet was
born in 1832, Cézanne in 1839, Monet in 1840,
and Thomas Eakins and Mary Cassatt in
1844. The lives of these three men have
certain features in common. They were of
modest origins, pursued other professions
before turning to full-time painting, were

62

partly self-taught and did not enjoy immediate recognition. They were also rather secretive men. The eldest, William Michael Harnett, was born in Ireland, but his family moved to Philadelphia a year later. They were not well-to-do, and at seventeen he started to train as a silver engraver while taking time to study at the Pennsylvania Academy of Fine Arts, where he met Peto, a fellow student. He moved to New York in 1871, attended the National Academy of Design and Cooper Union and at the age of twenty-seven abandoned silver engraving in favour of painting. His training had made him a meticulous craftsman, an essential quality for a trompe-l'oeil artist. At first, Harnett painted still-lifes. Then, during a trip to Munich between 1880 and 1886, he discovered and absorbed the Dutch tradition. On his return to the United States, he painted larger canvases and became a trompe-l'oeil painter whose works were admired (Plate 54 and frontispiece). He also influenced his younger contemporary, John Frederic Peto (Plate 53). An unlucky man, Peto was a musician from Philadelphia, where his work as a painter was completely ignored, prompting him to settle in New Jersey in 1889. Hardly more successful there, he fell into oblivion to the point that many of his works were later attributed to Harnett. The last of the three was John Haberle, who was born and lived in New Haven, Connecticut, where he worked for many years as an assistant in the Palaeontology Department at Yale University, though he had studied at the Academy of Design in New York. Haberle's trompe-l'oeil were mostly painted between 1887 and 1891 and became quite popular (Plates 55, 56). Like their lives, the works of these men show similarities. Their themes are in most cases essentially American. They used the simple domestic objects that belong to ordinary country people rather than artists' paraphernalia or decorative bric-à-brac. There is

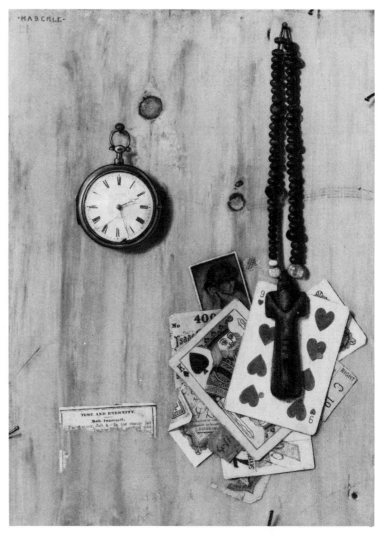

56. John Haberle (1856–1933): *Time and Eternity*. About 1890. Oil on canvas, 35.6 × 25.4 cm. (14 × 10 in.) New Britain, Museum of American Art

63

little trace of intellectual life in their paintings and, although their technique is necessarily traditional—there is only one way of painting a good trompe-l'oeil—their production is remarkable for its unity of style. Their works are not romantic, but sober and sometimes austere, depicting the traditional letter racks, but usually guns, violins, hunting objects and game, as well as the innovation of blackboards and photographs. Another common trait was the use of painted doors rather than bare wood panelling as background. Their paintings are rarely overcrowded and such simplicity in the choice of the objects as well as in the composition prompted contemporary critics to declare that they belonged to a poor man's world. Unfortunately, they were also ridiculed because of their genre. Detractors said that trompe-l'oeil was worthless imitation, devoid of passion, its task performed much better by photography and its only charm its deceptive character.

This was indeed a crucial period in the history of trompe-l'oeil, because the genre was threatened by the evolution of art away from the representation of reality. It could have disappeared altogether, were it not for a few men indifferent to fashion, craftsmen at heart, patiently devoted to painting the objects surrounding them, witnessing their time. And there was a small clientele able to appreciate the unassuming quality of works whose exact verisimilitude could only come from sheer virtuosity. After Harnett, Peto, Haberle and such followers as Chalfant and Keane (Plate 58), however, trompe-l'oeil artists became a rarity and the genre fell into neglect.

The new movements of twentieth-century art upset previous tradition even more than had the Impressionists and Cézanne, though society's taste was lagging well behind artistic development. The Cubists were flourishing in almost total obscurity in the 1910s and the Impressionists themselves had not yet become popular. Then, in the wake of the First World War and the upheavals it had brought about, a new generation of artists and intellectuals appeared, determined to attack directly the conventions of conservative society. They were the Surrealists, who chose sarcasm and humour as their weapons. They delighted in the unusual, the bizarre, and had made the new science of psychoanalysis one of their favourite studies. With the Surrealists, trompe-l'oeil came to life once more. They fully appreciated its illusionistic qualities, its wit and symbolism. They saw that perfection of rendering could make unusual subject-matter appear completely normal. Trompe-l'oeil became a game to which they added an intellectual dimension. They were not interested in its decorative side. Pierre Roy and Magritte are the best exponents of Surrealistic trompe-l'oeil and Pierre Roy also did some paintings in the genre's traditional style. Though perhaps no one would think of Magritte as a trompe-l'oeil painter, his series of canvases incorporating a landscape seen from a window deliberately aimed at its effect (Plate 57). They are among his most popular works and he treated this theme several times between the 1930s and the 1950s.

Even before the Second World War, American art had become quite independent and in turn exerted an influence on European art. Trompe-l'oeil continued to develop quite apart from all other movements, yet, as always, unquestionably remaining within its social environment. From the 1950s onwards, with the general post-war economic improvement, there was renewed interest in decorative arts, and trompe-l'oeil artists consequently benefited. Typical of this period is the Belgian

57. René Magritte (1898–1967): *La Condition Humaine I*. 1933. Oil on canvas, 100 × 81 cm. (39½ × 32 in.) Paris, private collection

64

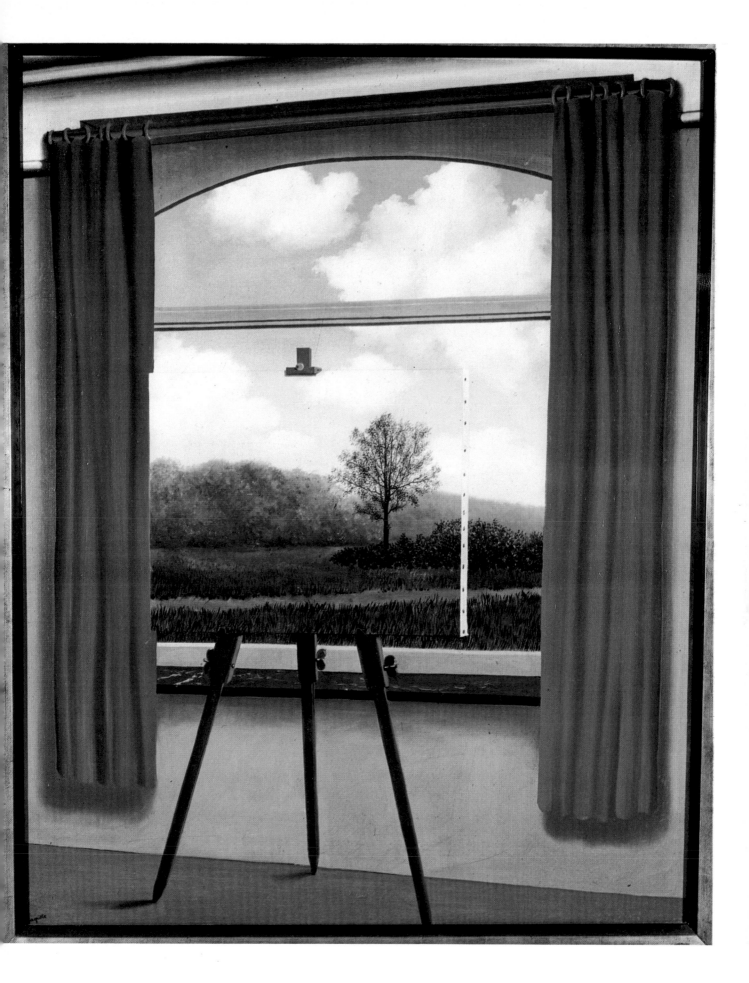

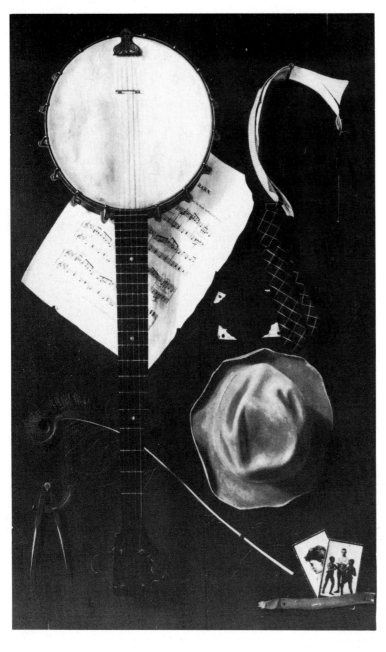

58. William Keane (active 1880–90): *The Old Banjo*. About 1889. Oil on canvas, 101.6 × 63.5 cm. (40 × 25 in.) San Francisco, M.H. de Young Memorial Museum

residence decorated by the Surrealist Paul Delvaux (Plate 59). We do not see many examples of trompe-l'oeil used as interior decoration because it is generally done for owners of private residences who do not seek publicity (Plate 60). Besides, trompe-l'oeil artists on the whole remain quietly absorbed by their craft and their painstaking works take a long time to achieve the desired perfection. They are often bought by keen collectors even before they are finished, and as a result only a few paintings find their way to the art galleries.

Trompe-l'oeil has continued to evolve since the 1960s and contemporary examples display great variety. There is no doubt that the old masters of the genre are widely known by the artists and still provide a strong source of inspiration. Some of them are deliberately painting objects reminiscent of the seventeenth and eighteenth centuries, arranging them as they would have been seen at the time. They do so for the sheer pleasure of the exercise, the proof that their technique is equal to their predecessors', or else because such works are commissioned to complement a particular style of furnishing. Martin Battersby, a British artist who has also designed sets for the theatre, has produced paintings in this style as well as more typically 1960s decorative canvases and others of Surrealistic inspiration (Plate 64). Many other artists have followed the nineteenth-century school of Harnett, Peto and Haberle, faithfully perpetuating all the trappings of this style. They exclude modern objects, use the traditional painted and hinged doors as background, depict old guns, and so on. The American Kenneth Davies and the British William Clayton have signed such works, which are only a part of their output. In the past, artists incorporated standard elements such as curtains, wooden panels, or the frames of letter racks from one century to another

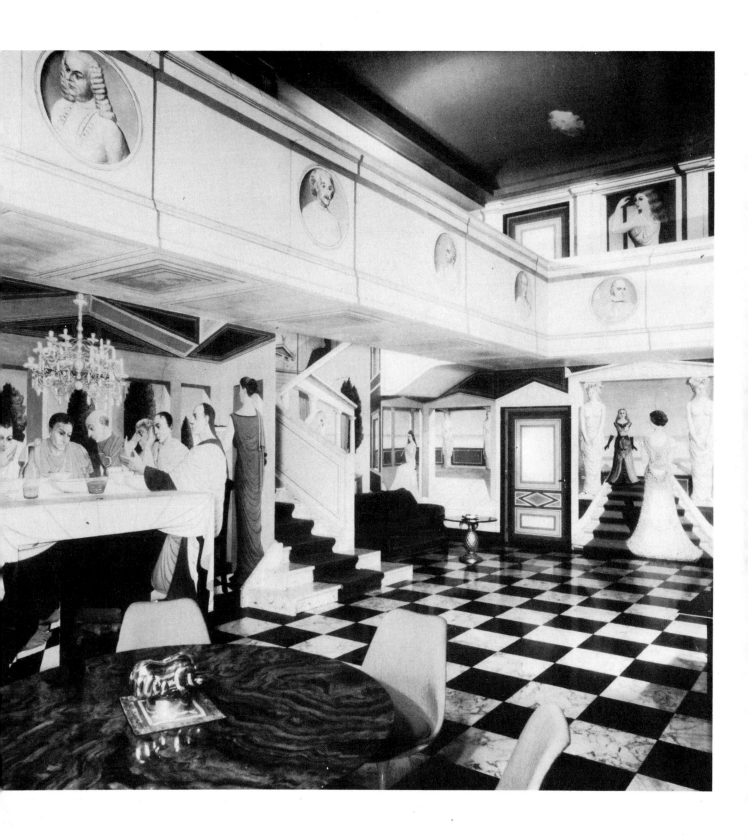

59. Paul Delvaux (b.1897): Decoration of a private residence, Brussels

60. Rex Whistler (1905–44): Mural in the dining room, Plas Newydd, Anglesey, Wales. 1936–8.
Oil on canvas, 3.81 × 14.33 m. (12½ × 47 ft.)

because such items were still in use, and the other objects figuring in their paintings belonged to their own time. Many modern artists feel free to adopt past styles to paint works of similar flavour, but there is a danger that these traditional styles may be employed only for the sake of nostalgia and, one suspects, commercial success. This kind of repetitive exercise lacks creativity and seems better suited to romantic advertisements or calendars. More interesting types of trompe-l'oeil belong fully to our era and they are of great and lively variety. There are, of course, the modern versions of simulated bookcases and shelves laden with domestic objects. The paper theme has been up-dated by the American Eliot Hodgkin, who stacked sheets on a spindle as shopkeepers or office clerks do. The British Harrisons, father and son, depict the backs of canvases, as do Lincoln Taber and others, and tools, musical instruments and crockery in a neat, perfect, unemotional manner (Plate 62). The British, although they exhibit their works from time to time, work in

relative isolation. In France, the painter Henri Cadiou formed, in 1960, a group of trompe-l'oeil artists who have promoted themselves and exhibited abroad, notably in New York and in Canada. They have a pleasing style, softer and less rigorous than the British artists, who, however, tend to achieve greater illusionistic effects. Painters like Cadiou, Gilou and Le Prince solve the problem of the human presence by using dummies, but the latter are given too much life, which adds to the ambiguity of the painting but dissipates the illusion.

For the first time since the great age of still-life in the seventeenth century, trompe-l'oeil can now be included in a contemporary art movement. The Super Realists evolved in the 1960s from the increasing prevalence of commercial imagery in America—in advertising, television and photography. Most of the first American Super, Hyper or Photo Realists used techniques completely opposed to those of trompe-l'oeil artists: they projected a given image—often an ordinary picture from daily life like a snap-shot—magnified on to a large

69

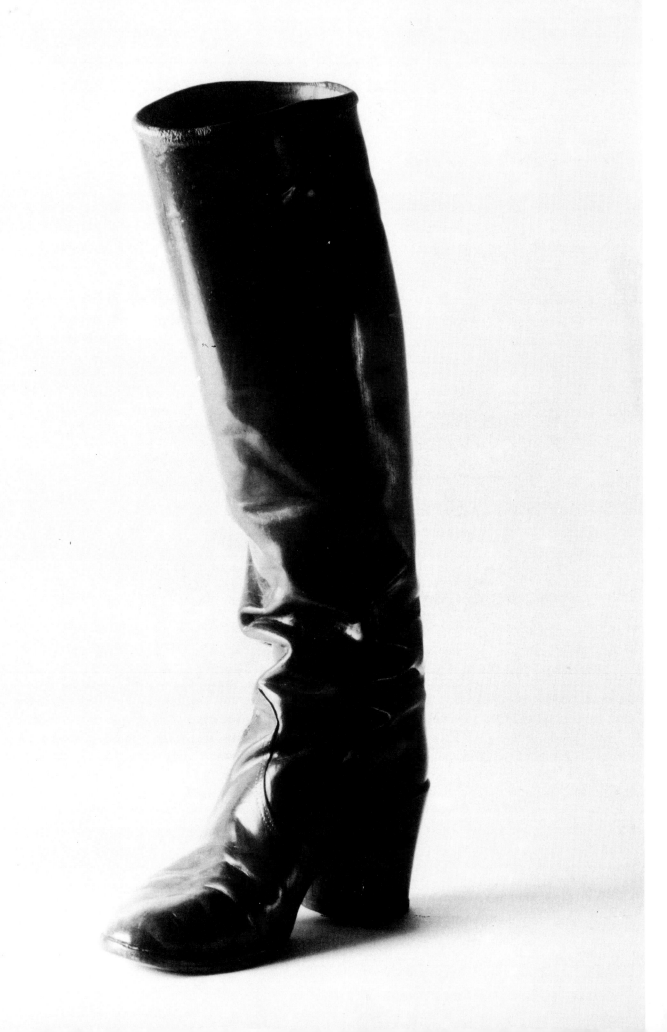

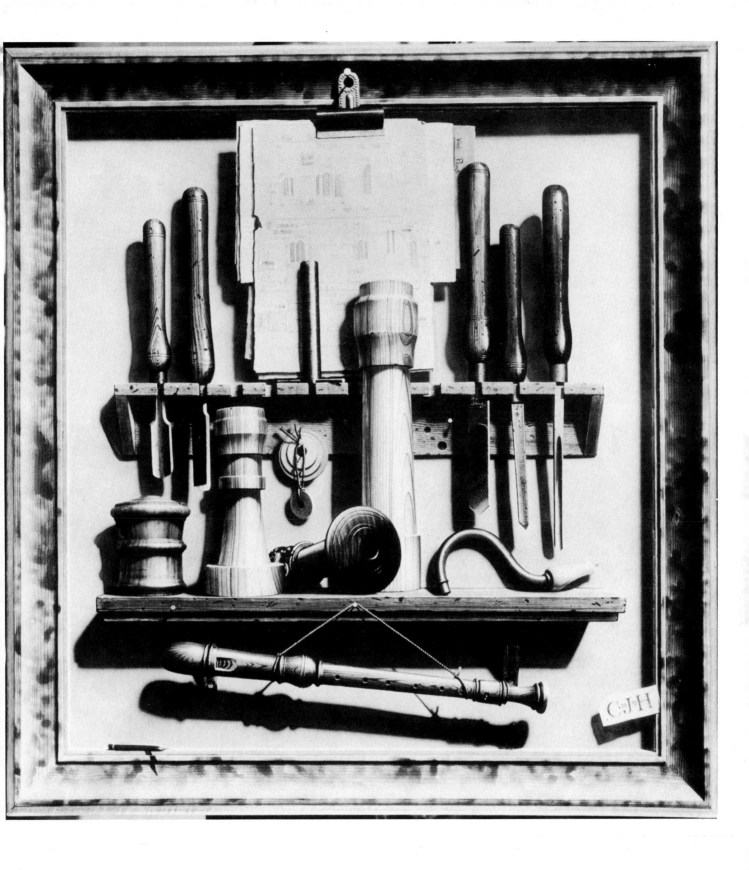

61 (left). Christian Renonciat (b.1947): *Wooden Boot*. 62 (above). C. J. Harrison: *Tools*. 1975. Oil on canvas.
Height 40 cm. (15¾ in.) Paris, Galerie de Luxembourg London, Collection Mrs Hyman Solomons

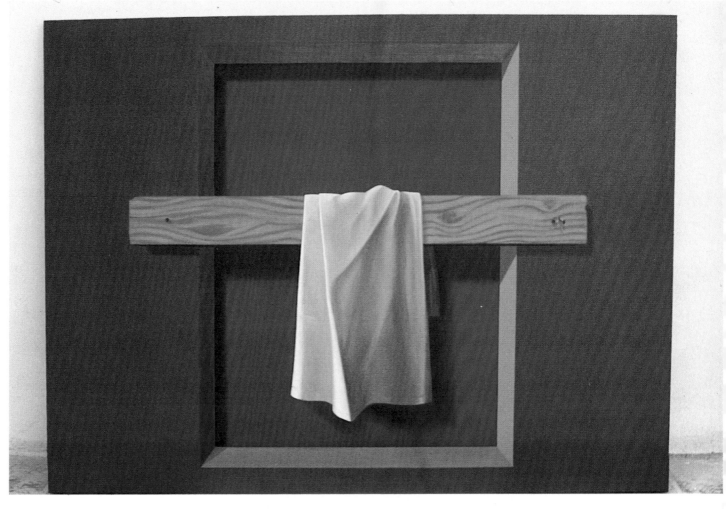

63. Domingos Pinho: *O Manto de Veronica*. 1973.
Oil on canvas, 89 × 120 cm. (35 × 48 in.) Lisbon, Artist's own collection

canvas which they then air-sprayed according to the colours of the original slide. The process requires skill but is relatively quick. Their followers, particularly the more craft-oriented Europeans, tend to achieve a similar effect of realism by means of traditional brushwork. Depending on the composition, a trompe-l'oeil artist can turn out works that are purely Super Realistic and, conversely, the Super Realist artist can turn out excellent trompe-l'oeil. This is the case in some paintings by the Portuguese Domingos Pinho (Plate 63), who did not necessarily intend to deceive the eye.

On the other hand, Harrison father has created some very good Super Realistic works—quite unintentionally—by representing only parts of objects which we then have to imagine in their entity outside the frame. Some French painters produce excellent trompe-l'oeil that can be equally attractive to people fond of Super Realism. Claude Yvel's and Jean Malice's works are of perfect quality, the subject-matter not only contemporary but also rendered with a superb photographic technique (Plates 65, 66).

Sculptors have also been tempted by Super

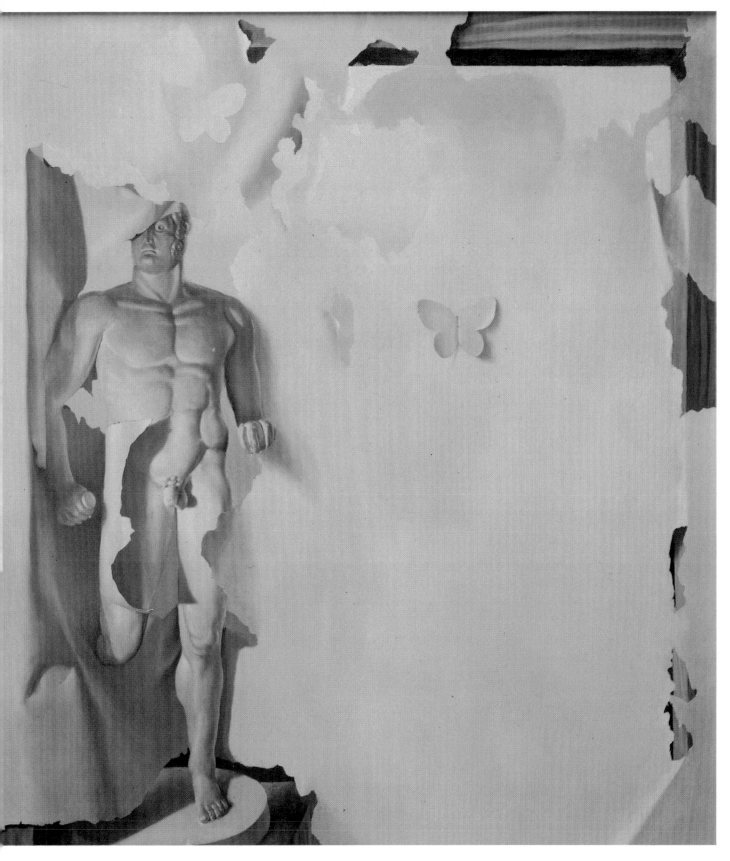

64. Martin Battersby: *Hercules.* 1975.
Acrylic on canvas, 121.9 × 96.5 cm. (48 × 38 in.) Artist's own collection

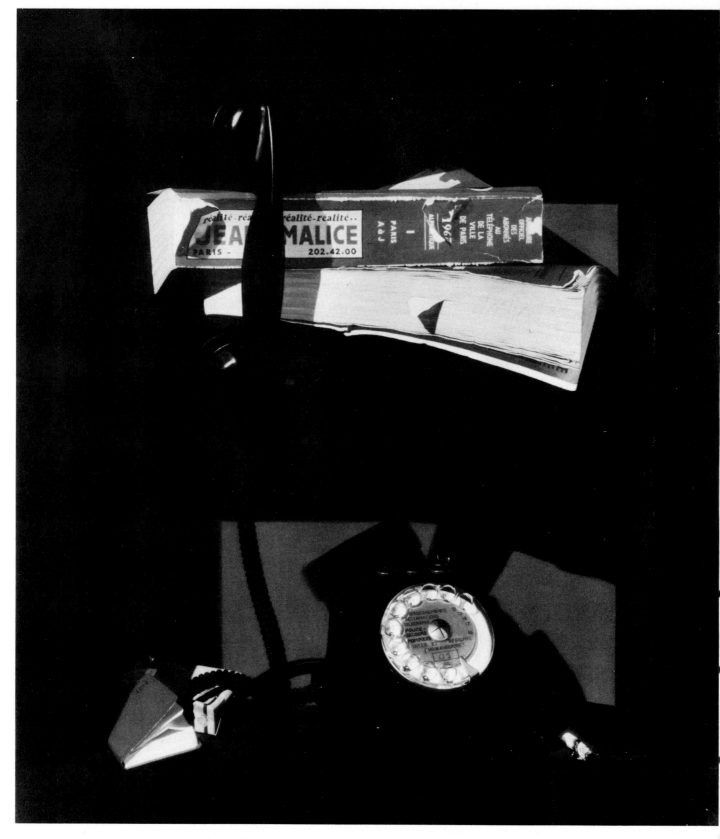

65 (above). Jean Malice (b.1930): *Le Téléphone*. 1970.
Acrylic on canvas, 61 × 50 cm. (24 × 19⅝ in.) Paris,
private collection

66 (right). Claude Yvel (b.1930): *After the Race*. 1973.
Oil on canvas, 53.3 × 45.7 cm. (21 × 18 in.) Paris,
Galerie du Luxembourg

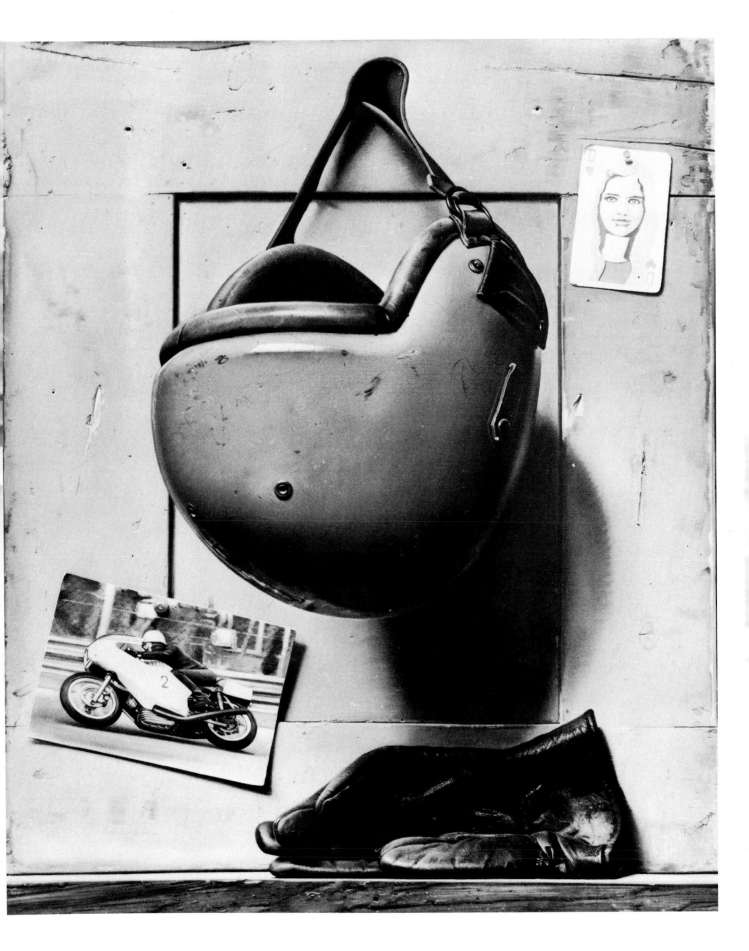

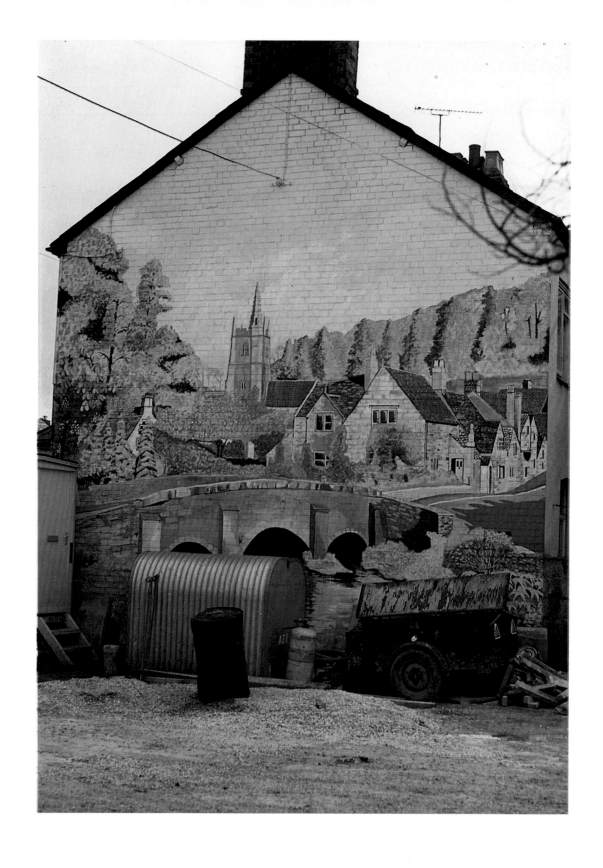

67–69. Three out-of-door murals from England. *Above*. This country scene on a wall in Swindon represents the beauty spot of Castle Combe. It was painted by the local Scout troop. *Top right*. A shop front in Moor Court, Sunderland, painted by Ken Watts. *Right*. Peter Rich's mural on the wooden fence in his own London back garden.

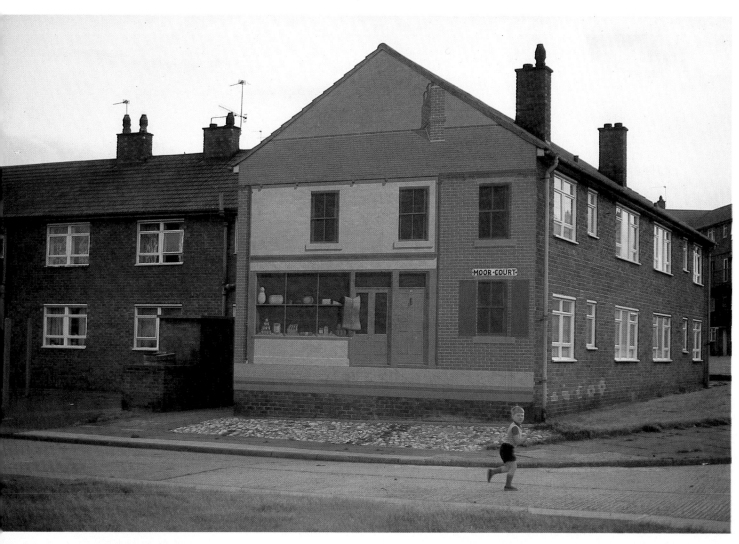

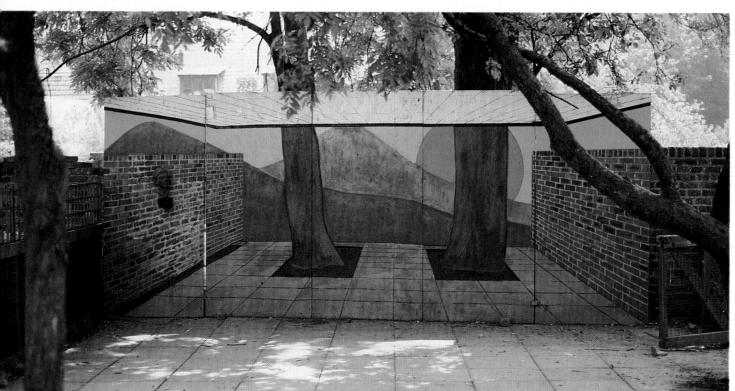

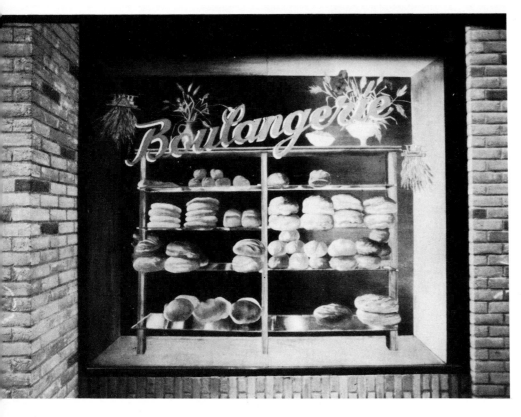

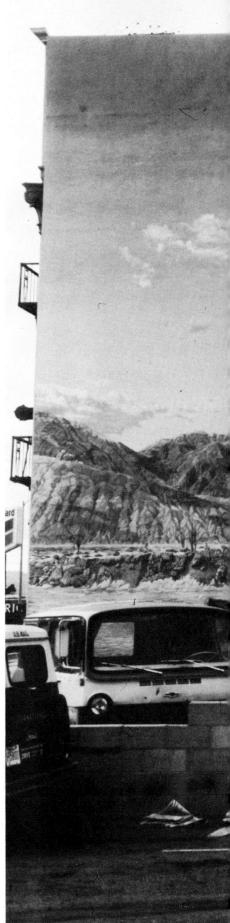

70 (above). Philippe de Gobert: Bakery window in Louvain. Wall painting

71 (right). Collapsed bridge. 1974. Painted wall in San Francisco. Artist unknown

Realism and have achieved similar trompe-l'oeil effects, whether intended or not. The American Marilyn Levine's ceramic golf bag and the French Christian Renonciat's wooden boots (Plate 61) and blankets, for instance, could deceive anyone. It has also been argued that John de Andrea's and Duane Hanson's sculptures are trompe-l'oeil as well, but one always has doubts whenever life is absent from a lifelike human representation. In a completely different category, it can be argued that optic artists have achieved good illusionistic effects. Although it is tempting to transfer trompe-l'oeil from realism to abstraction, neither Bridget Riley, nor Soto, nor any other optic artist can be said to work at deceiving

78

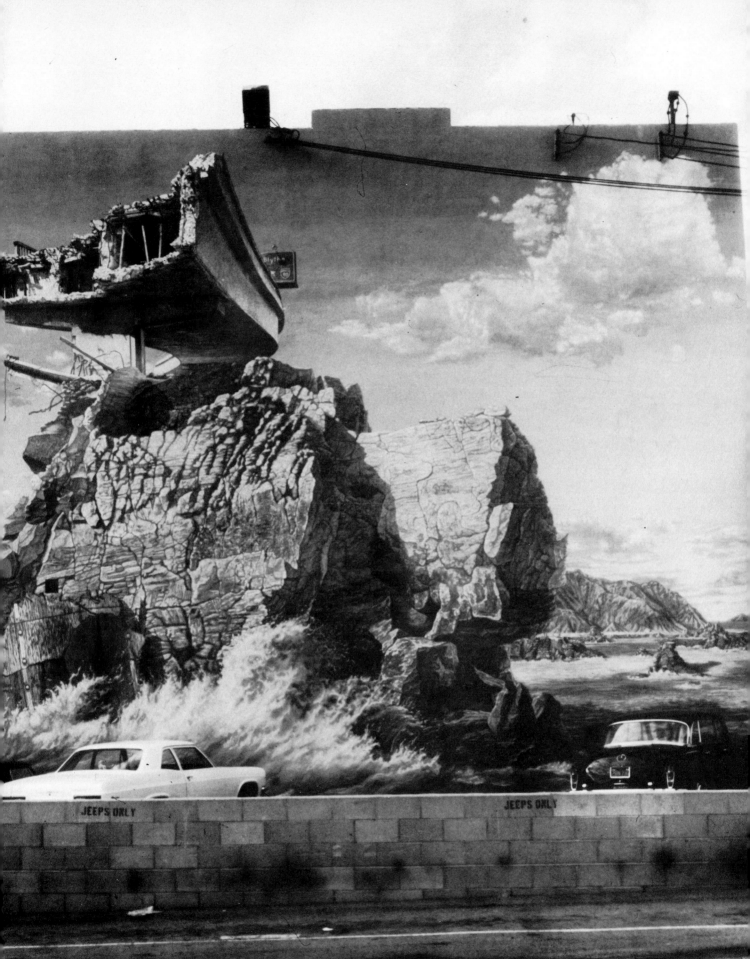

the eye by creating an illusion. Escher is very much a borderline case, as he really deceives the eye with clever games of perspective. But Escher was not an abstract artist.

There are few trompe-l'oeil objects nowadays and few intarsie either, probably because the cost of good intarsia is too high to attract many commissions, but Roger Natter has made beautiful ones in the late eighteenth-century style for the French cabinet-maker Jansen. Out-of-doors murals are a most interesting form of contemporary trompe-l'oeil. They are no longer designed as refined bourgeois decorations but as a more popular and spontaneous reaction against the uniformity, lack of imagination or downright ugliness of modern cities. These murals have been painted in America as well as in several European countries, sometimes by a single artist or by several artists working in a team (Plates 67–72). Many are extremely effective. They can be regarded as part of a general trend towards brightening up people's lives by decorating large areas of wall space found in urban centres rather than leaving them bare and dirty. This new kind of trompe-l'oeil can be enjoyed by everyone, and one feels certain that the genre will not die away so long as there will be room for a sense of incongruity, fantasy and enjoyment among us.

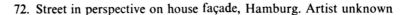

72. Street in perspective on house façade, Hamburg. Artist unknown